CONJURING **PARADISE**

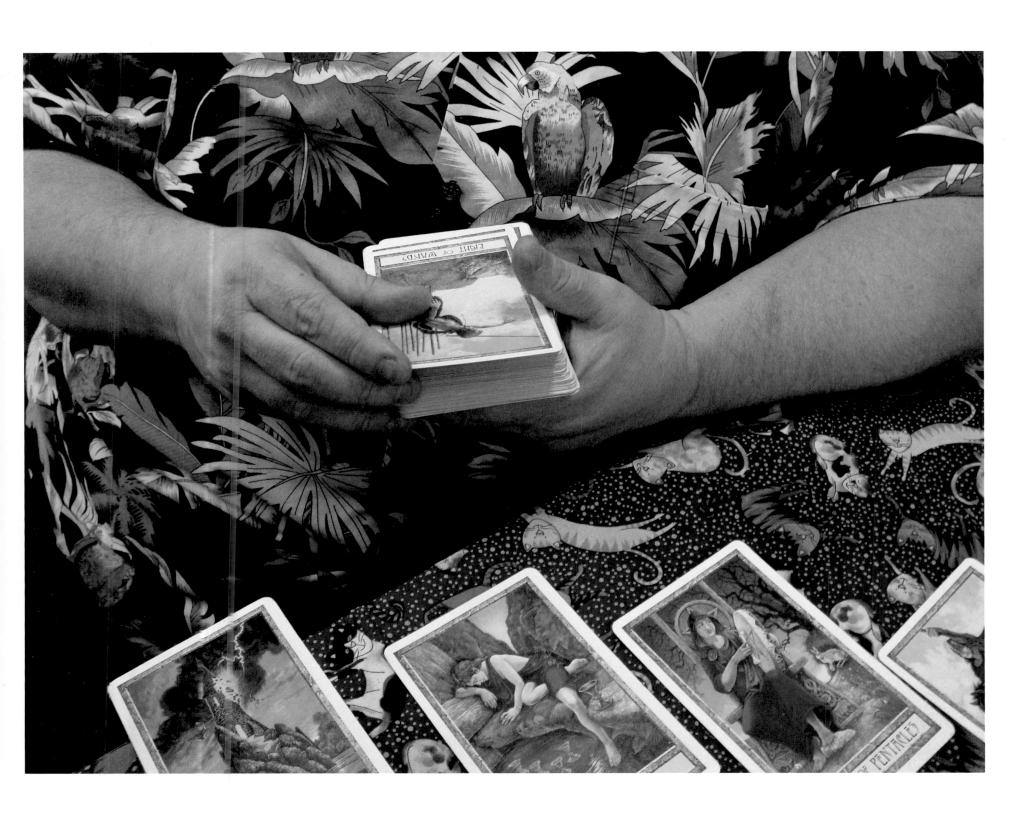

FRANK KAREL III (1935–2009)

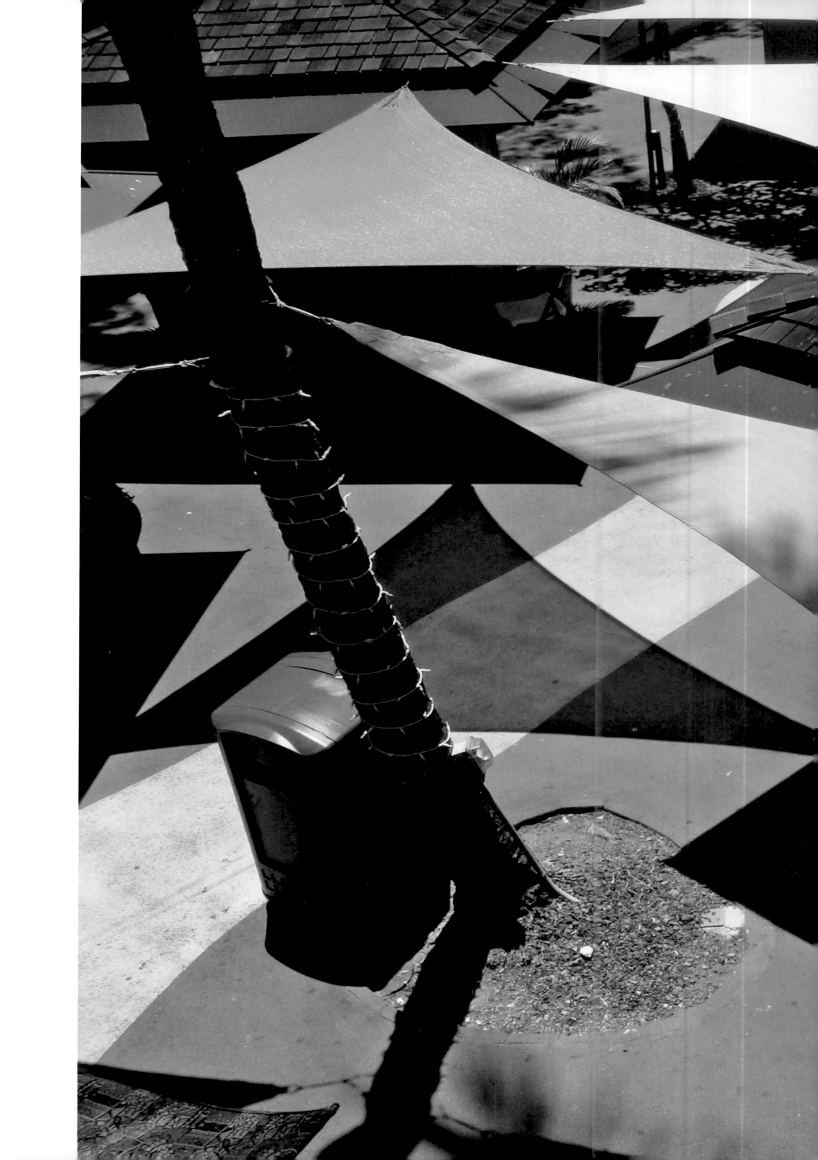

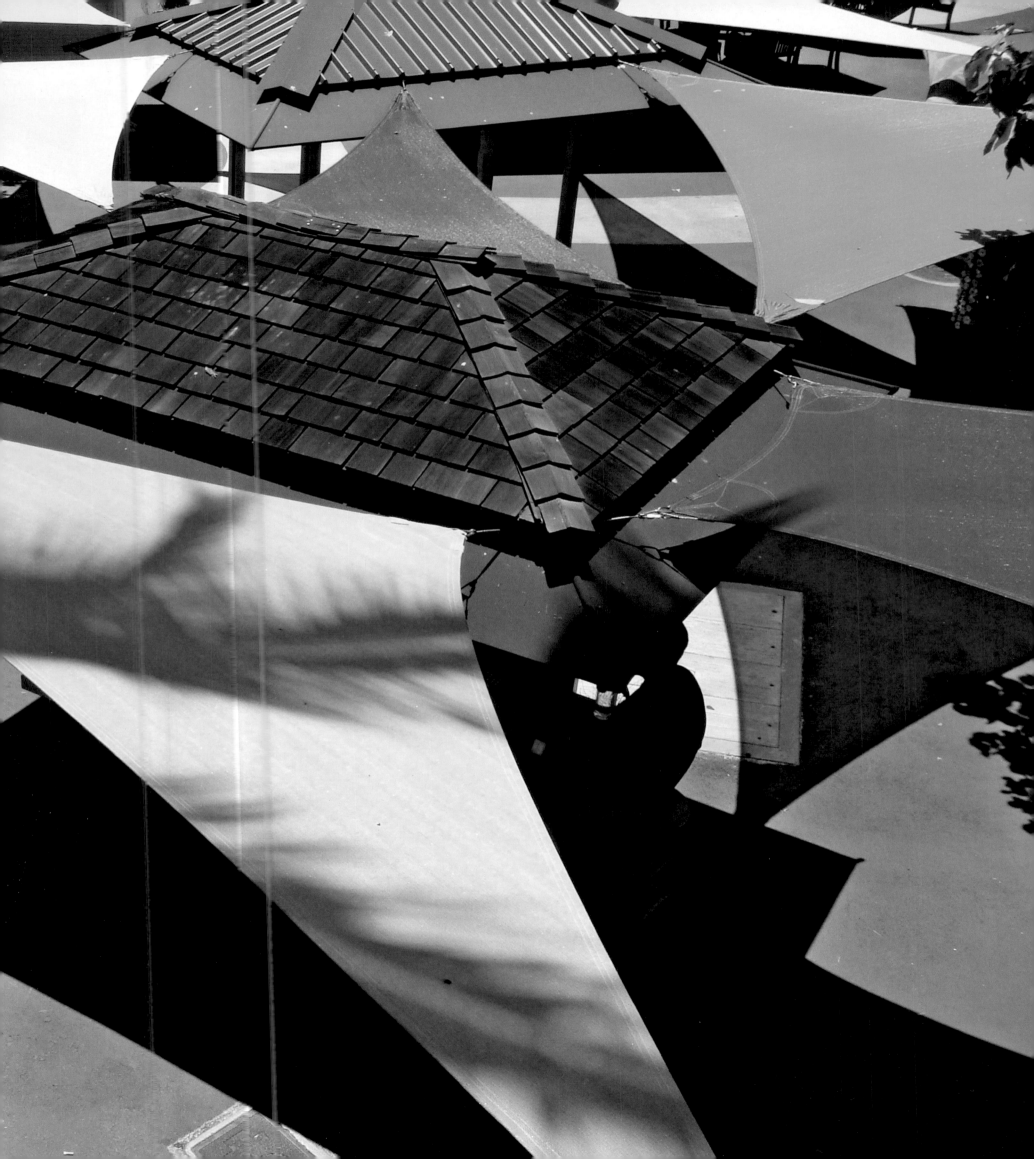

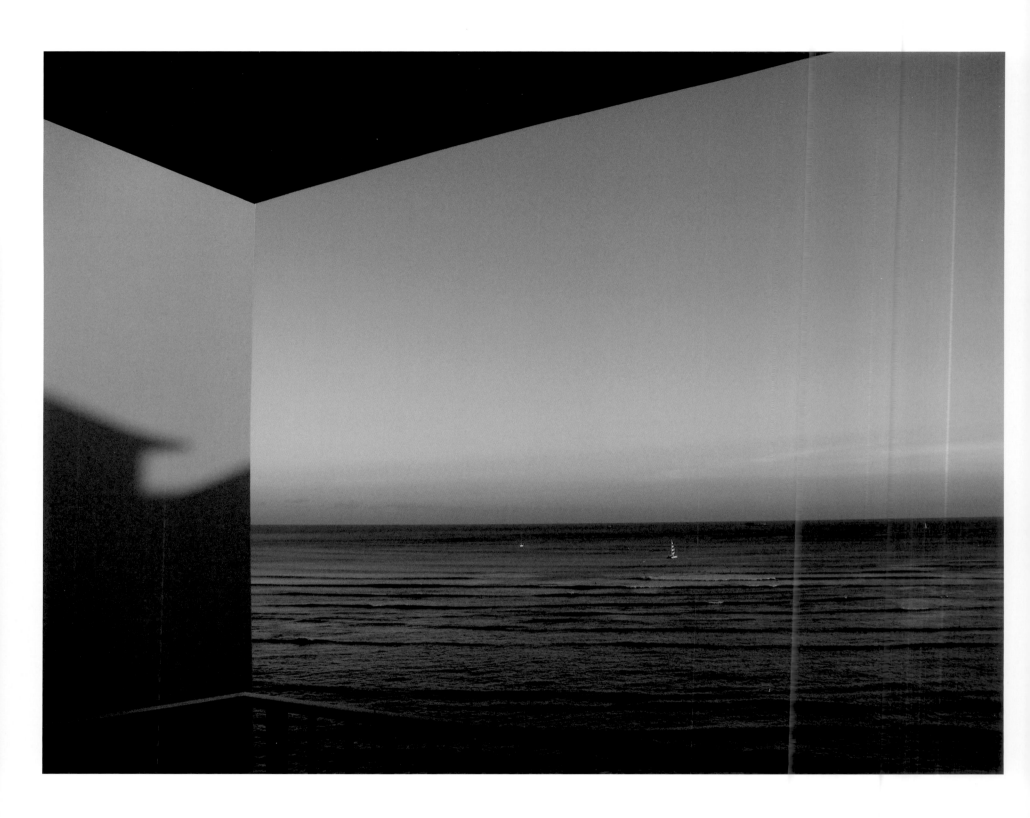

CONJURING **PARADISE**

BETSY KAREL

RADIUS BOOKS

SLANT

Can or can't you feel
a dominant handedness
behind the randomness
of loss? Does a skew
insinuate into the
visual plane; do
the avenues begin to
strain for the diagonal?
Maybe there is always
this lean, this slight
slant. Maybe always
a little pressure
on the same rein,
a bias cut to everything,
a certain cant
it's better not to name.

Kay Ryan

From *The Best of It:
New and Selected Poems*, 2011

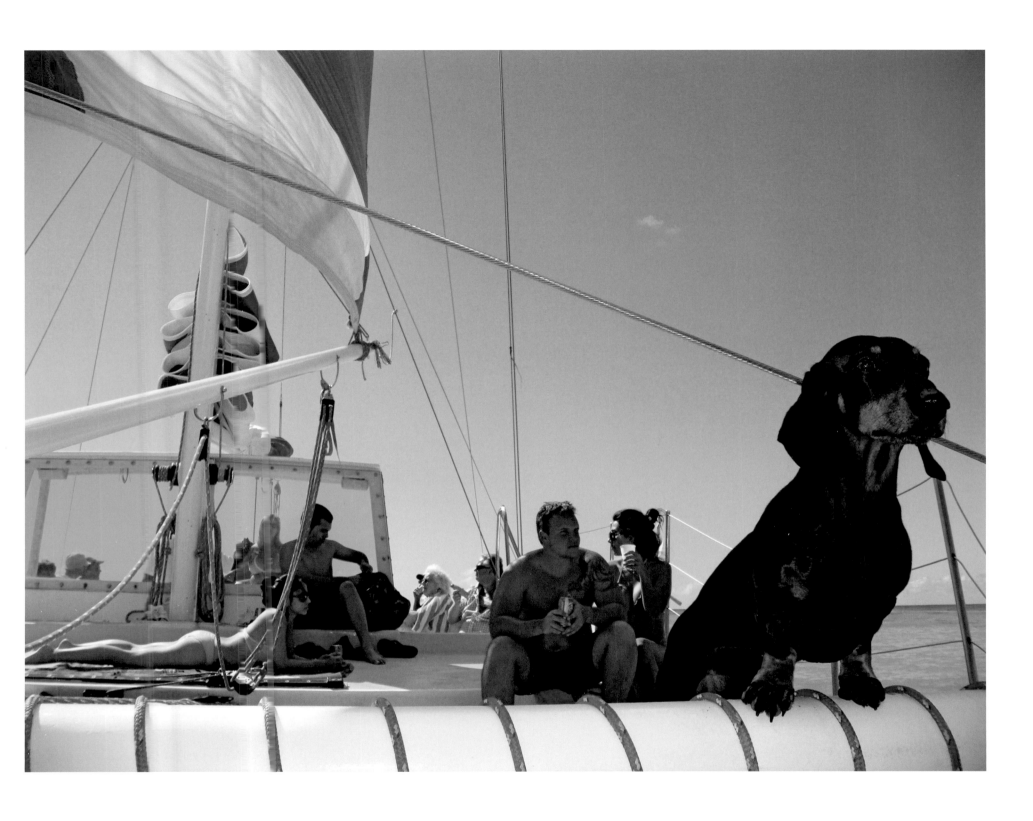

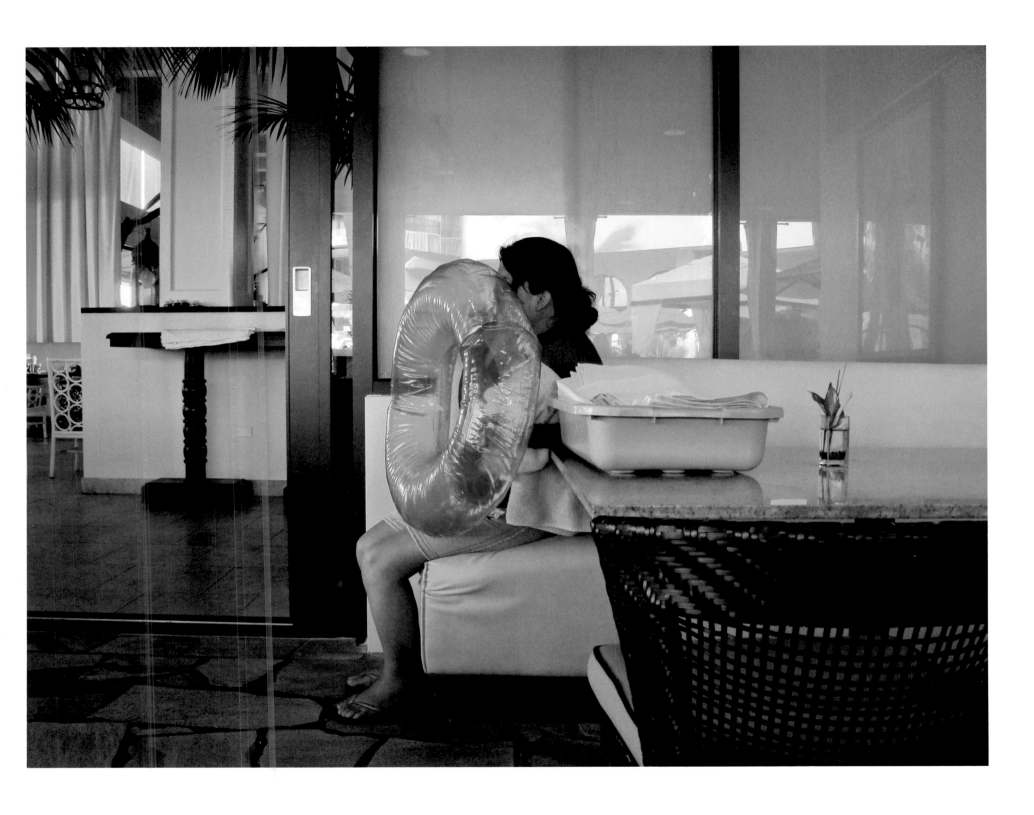

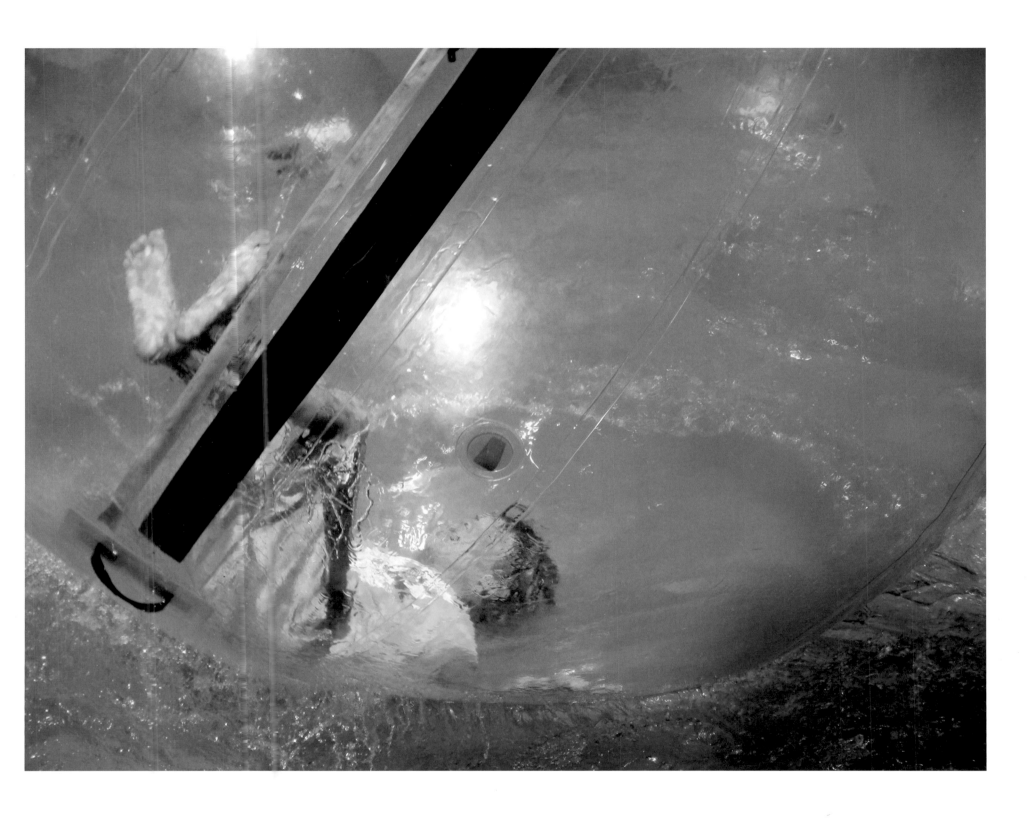

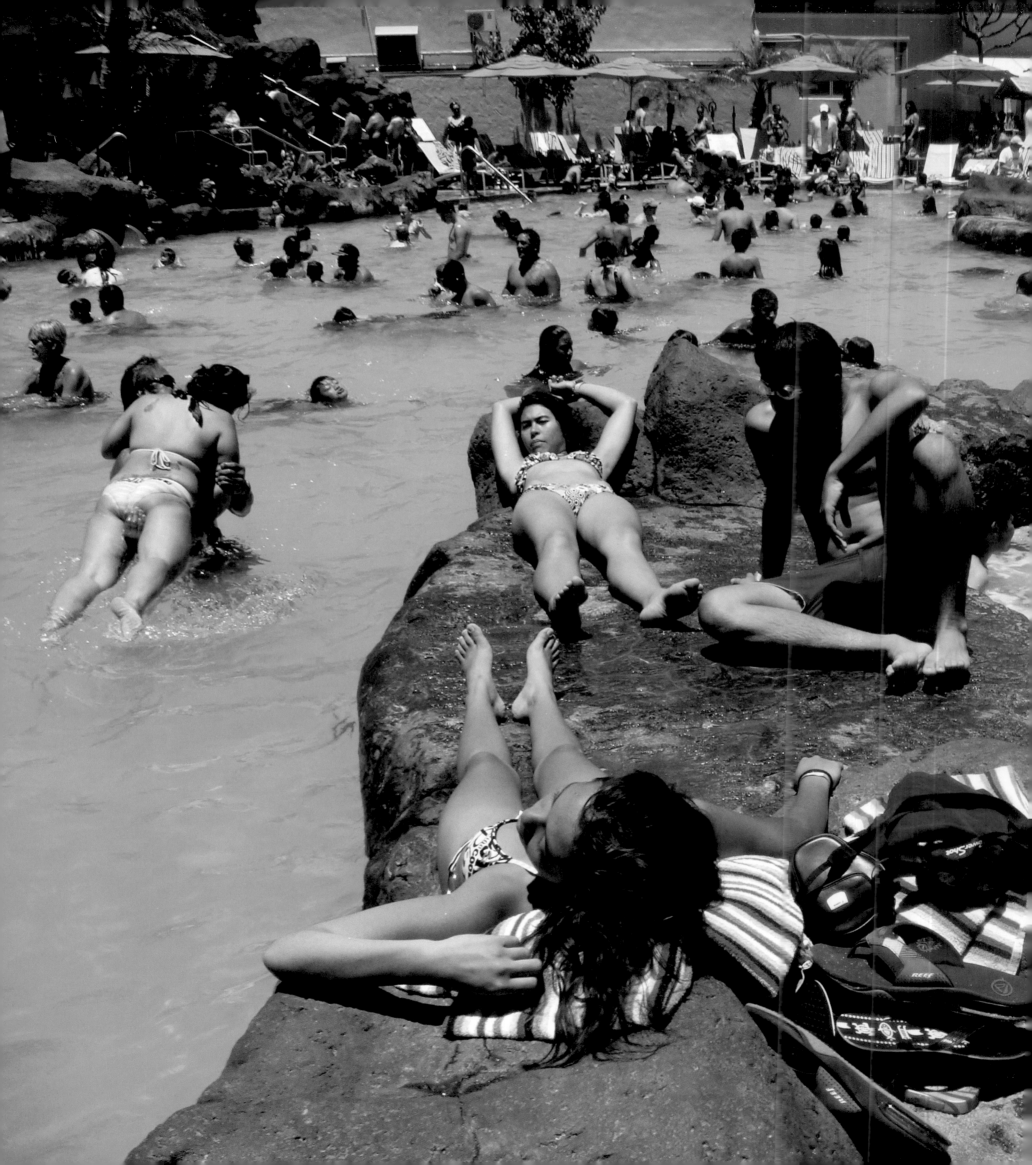

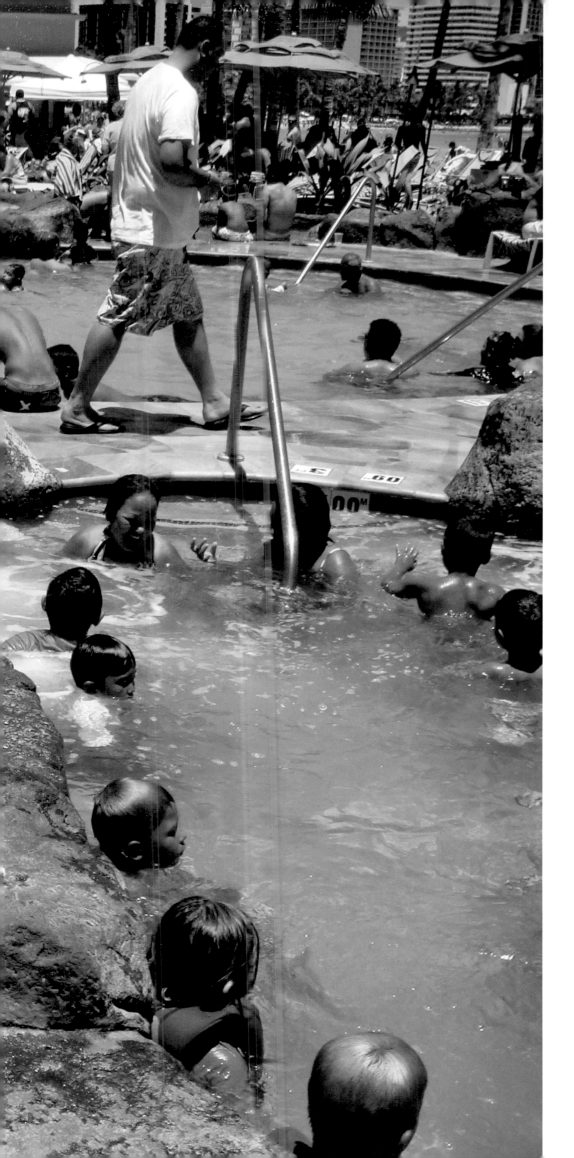

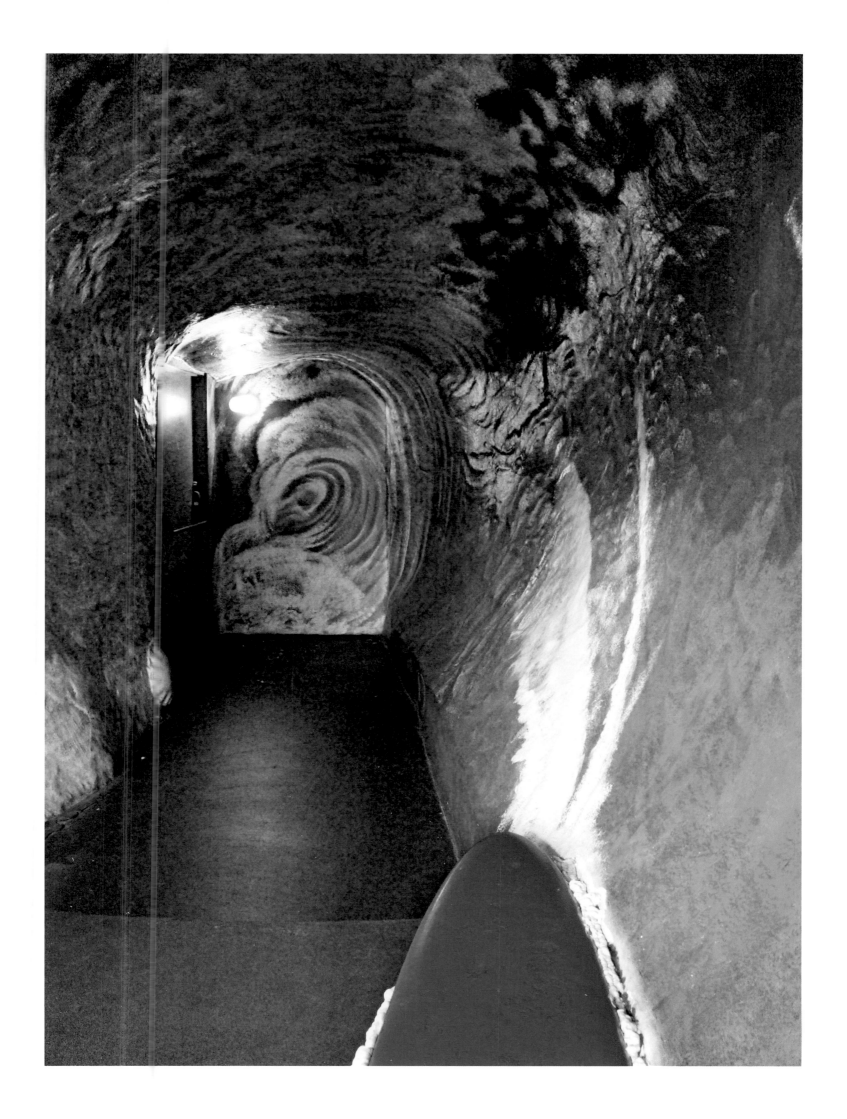

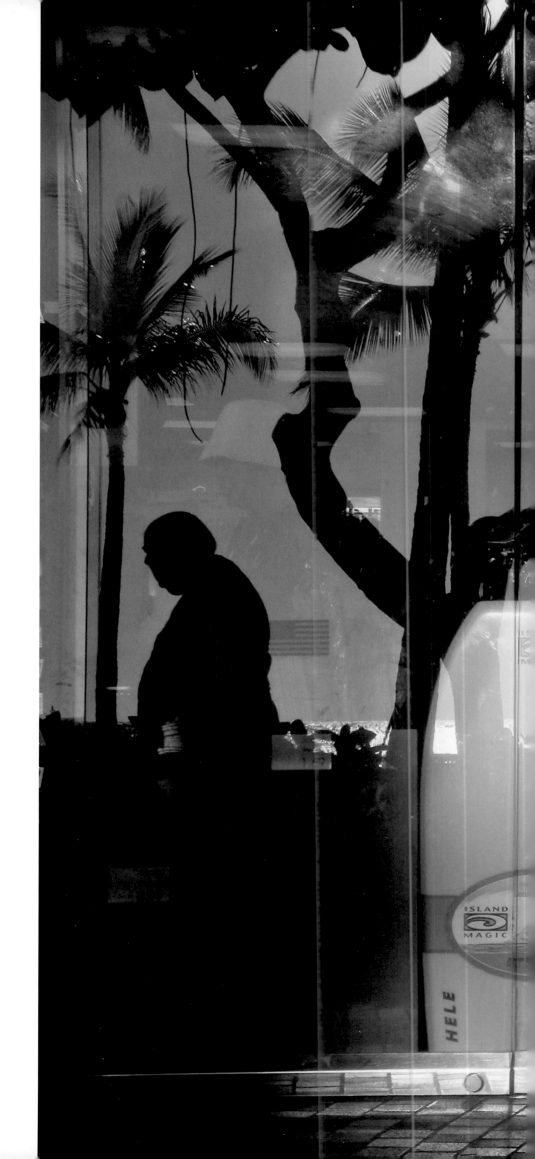

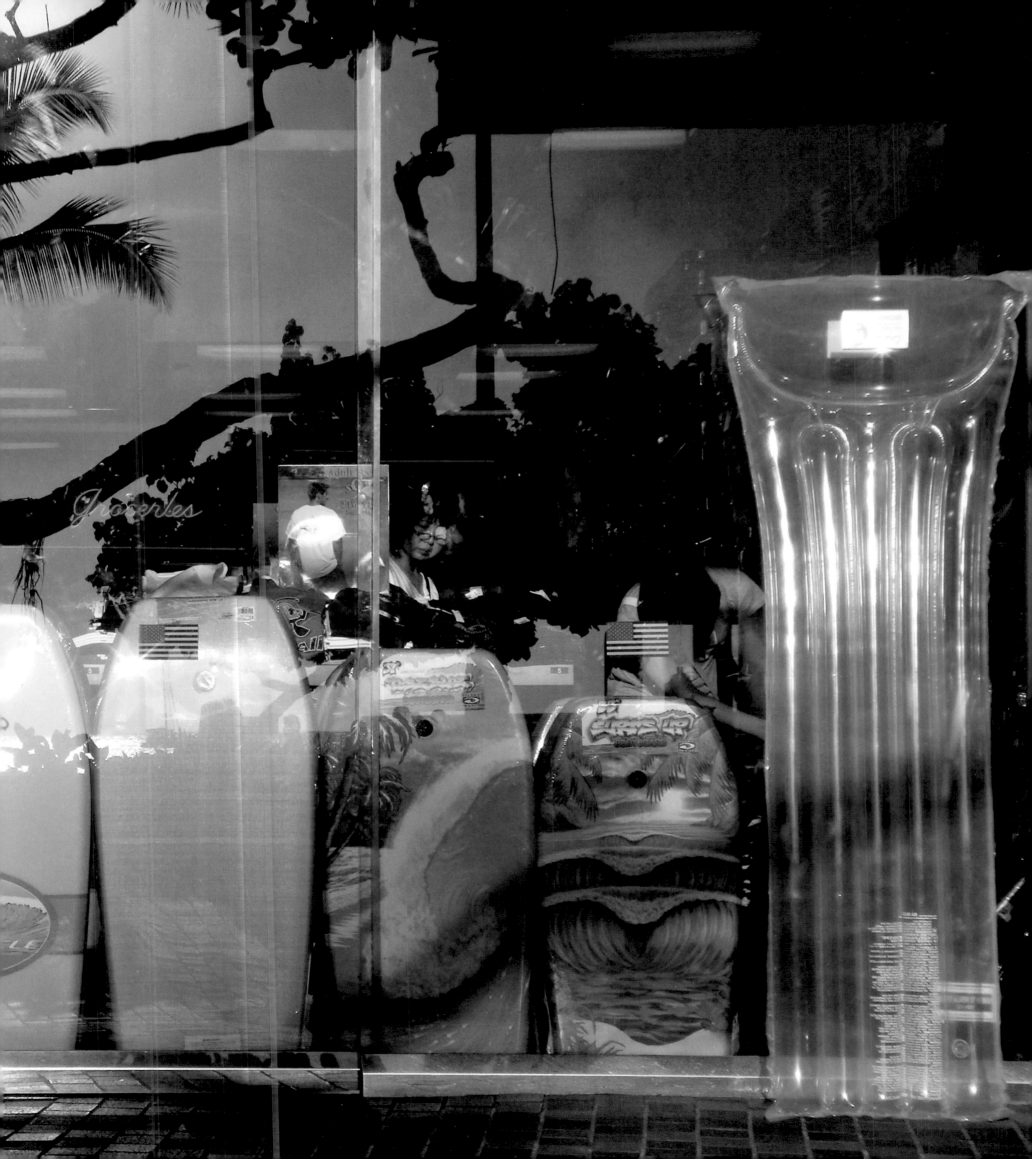

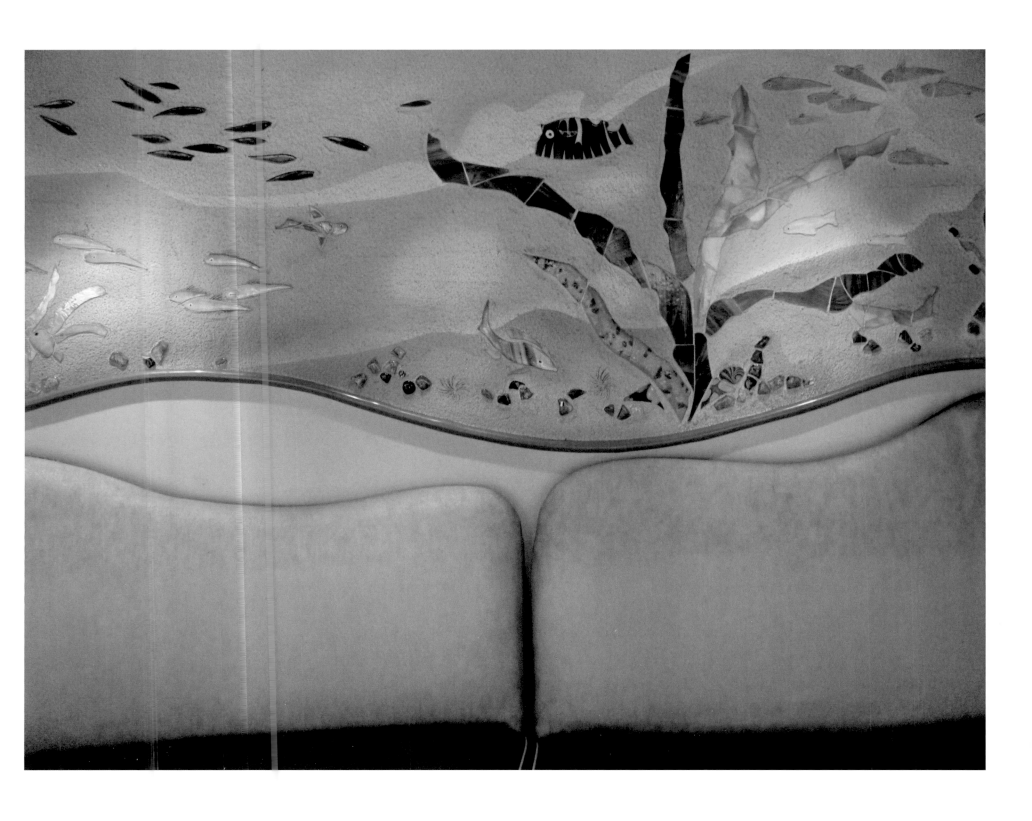

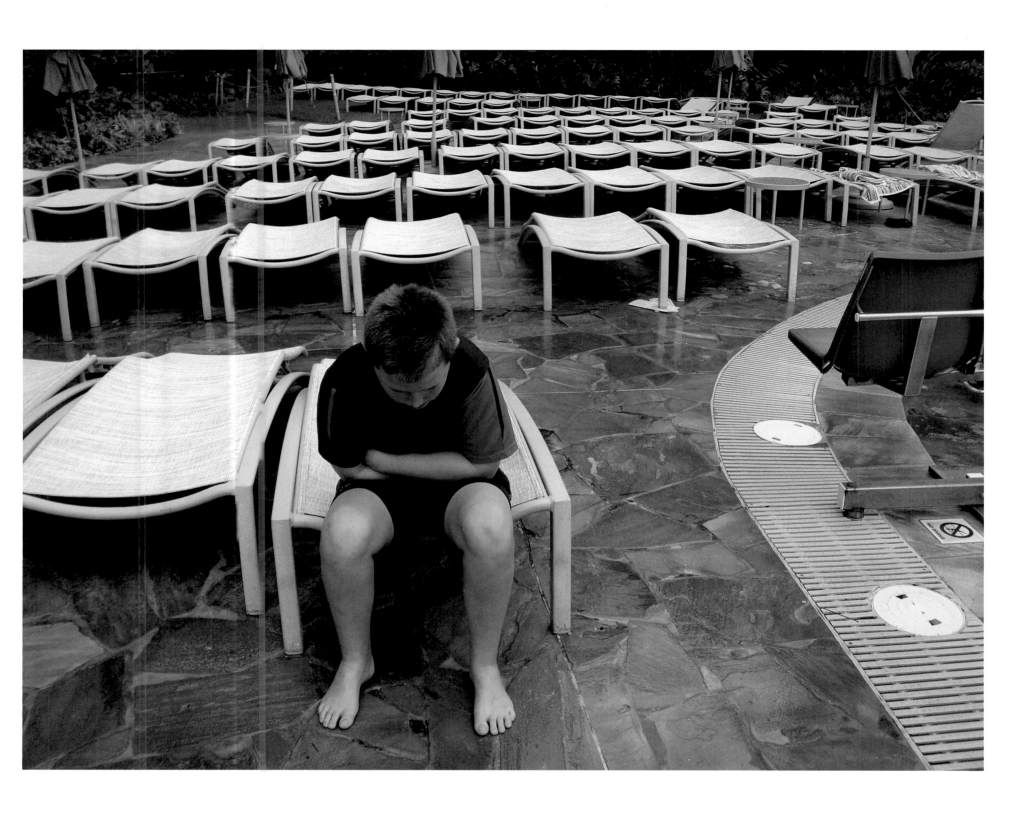

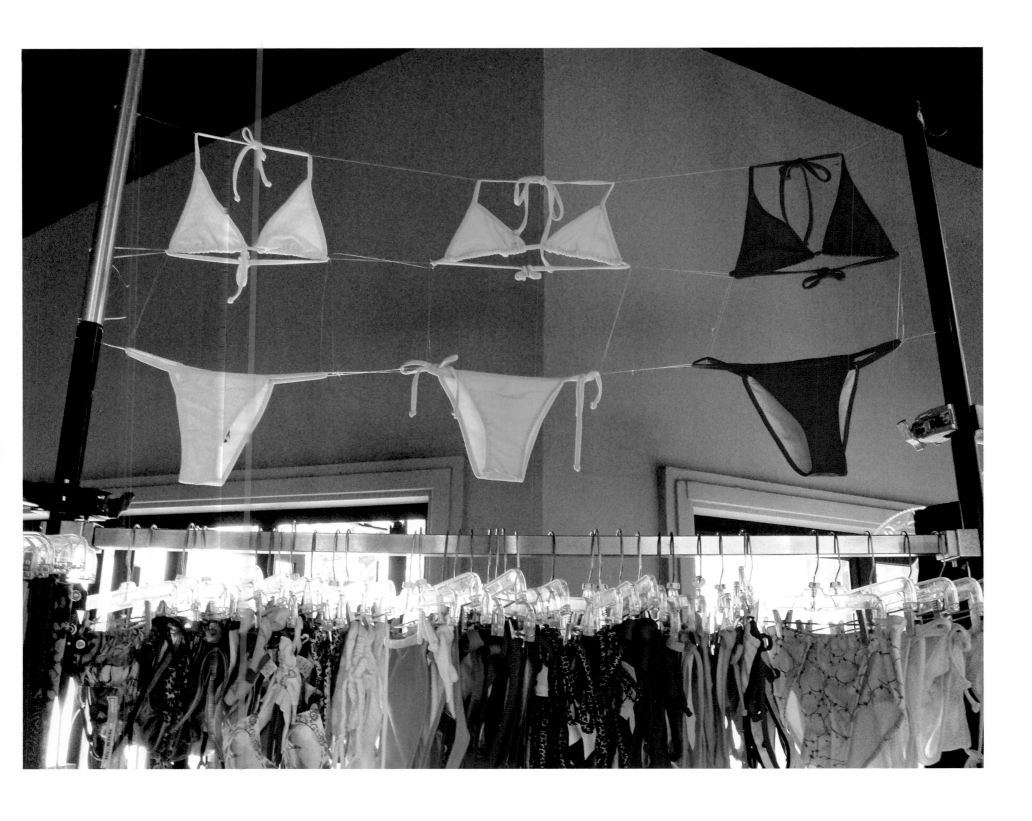

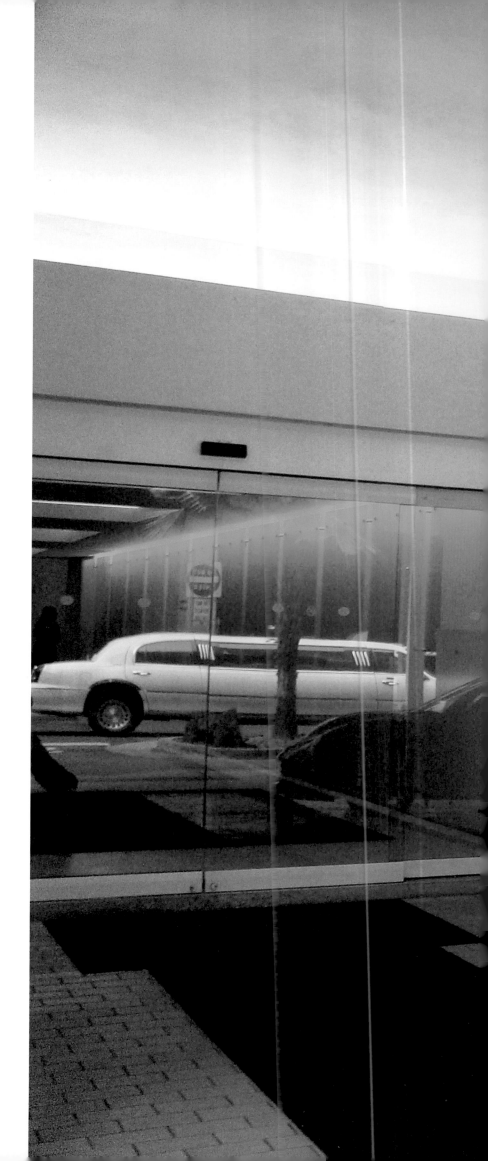

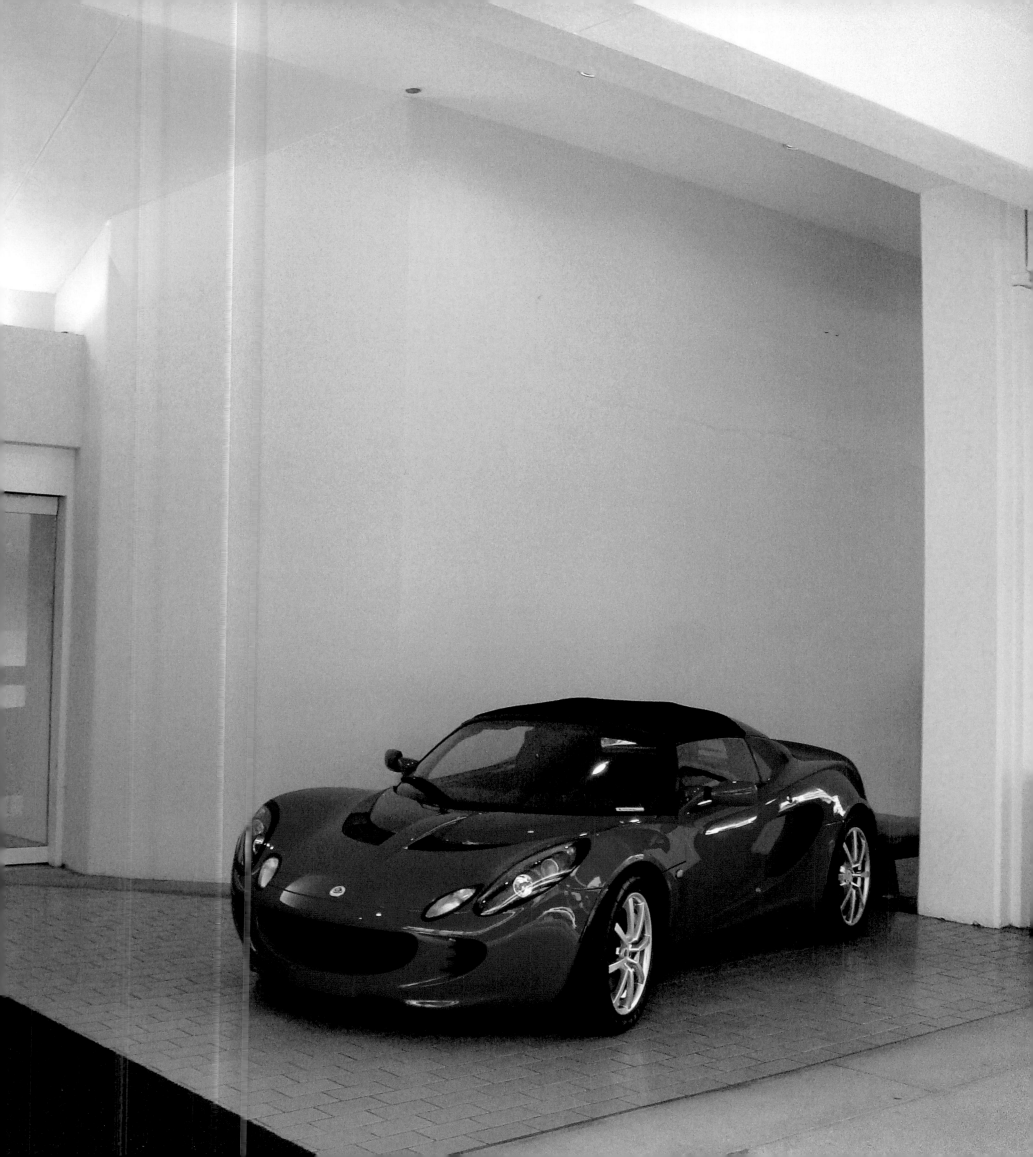

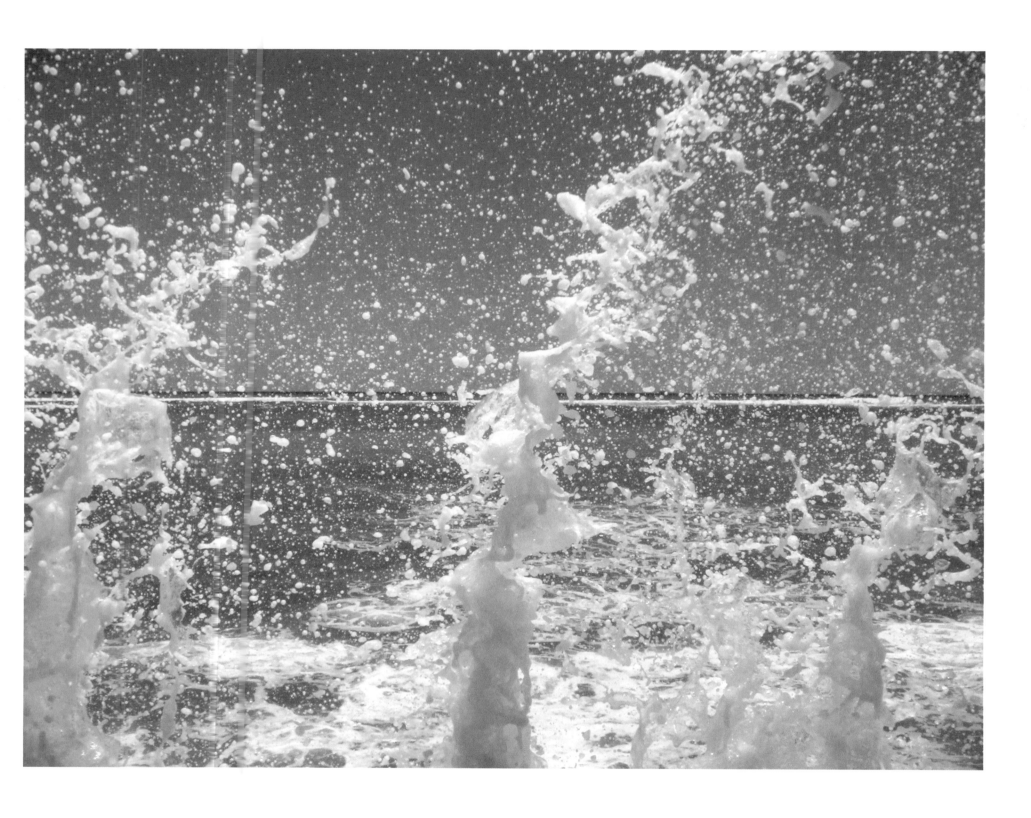

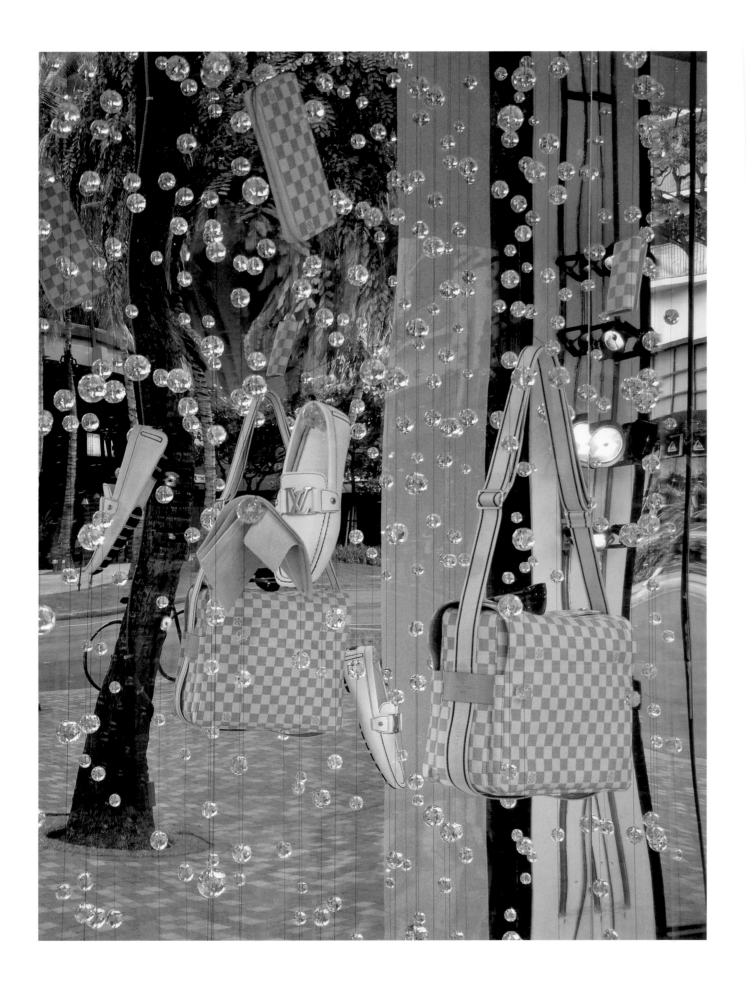

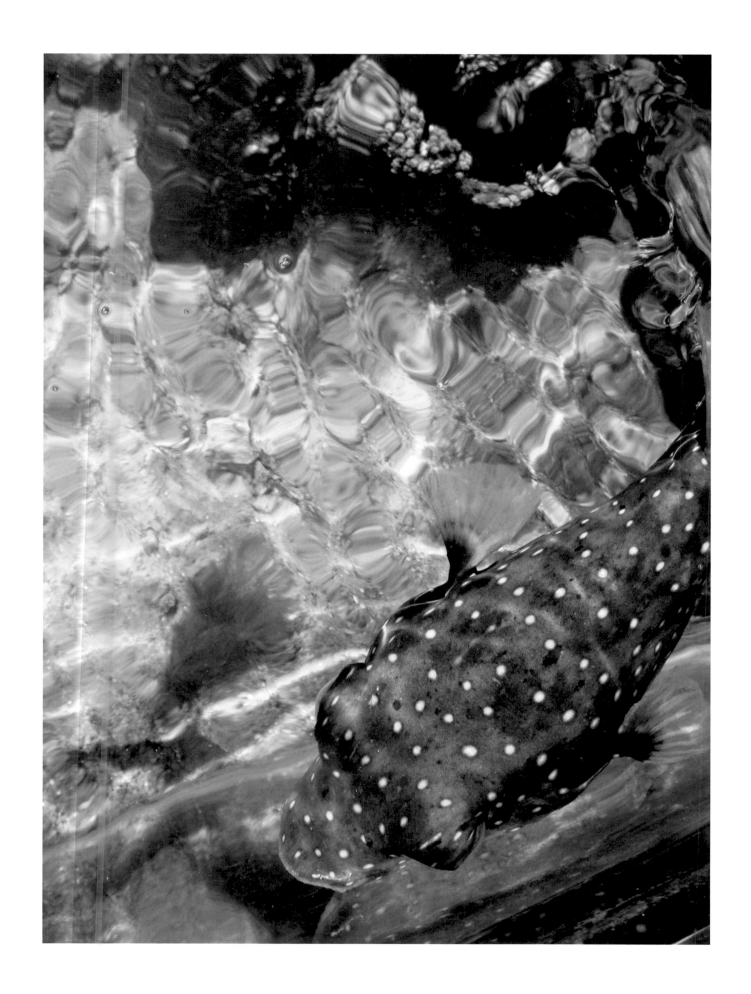

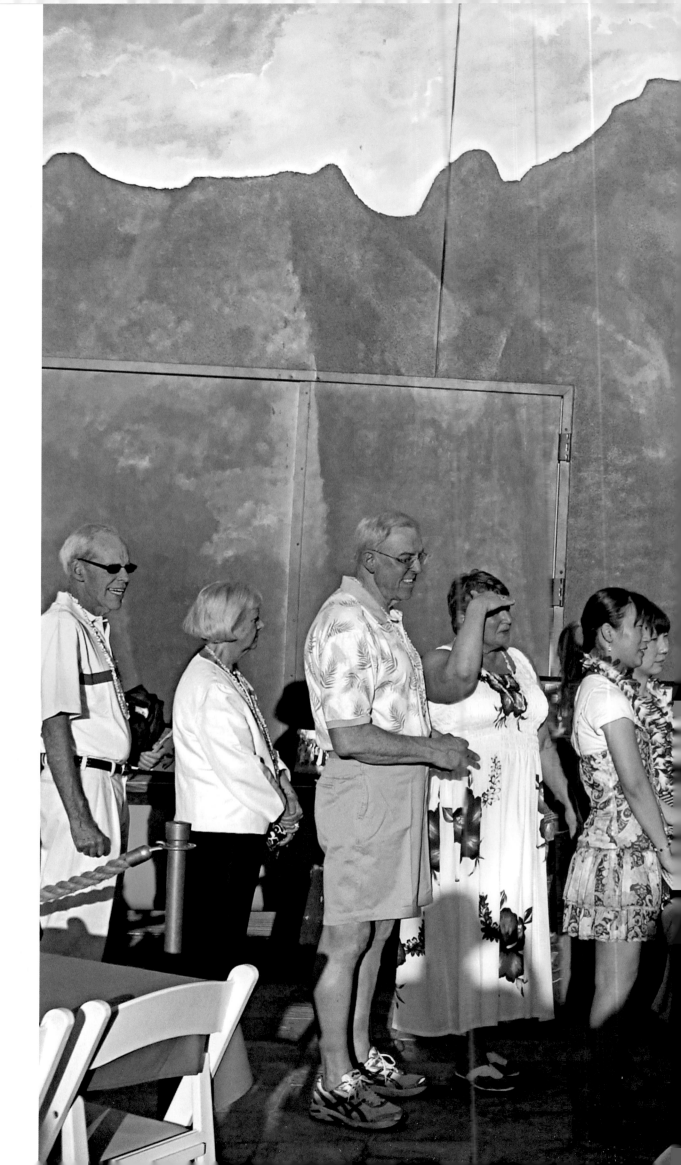

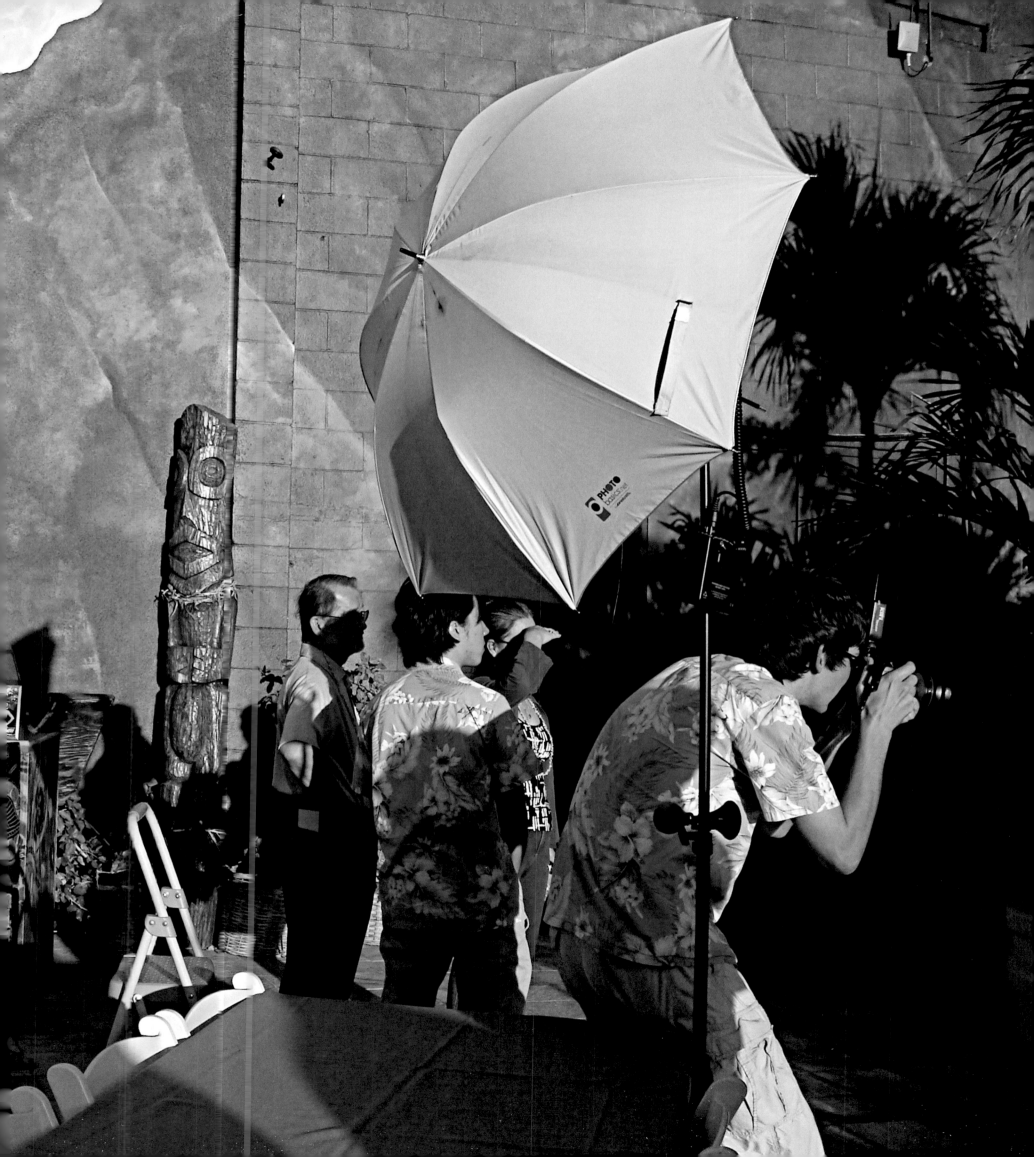

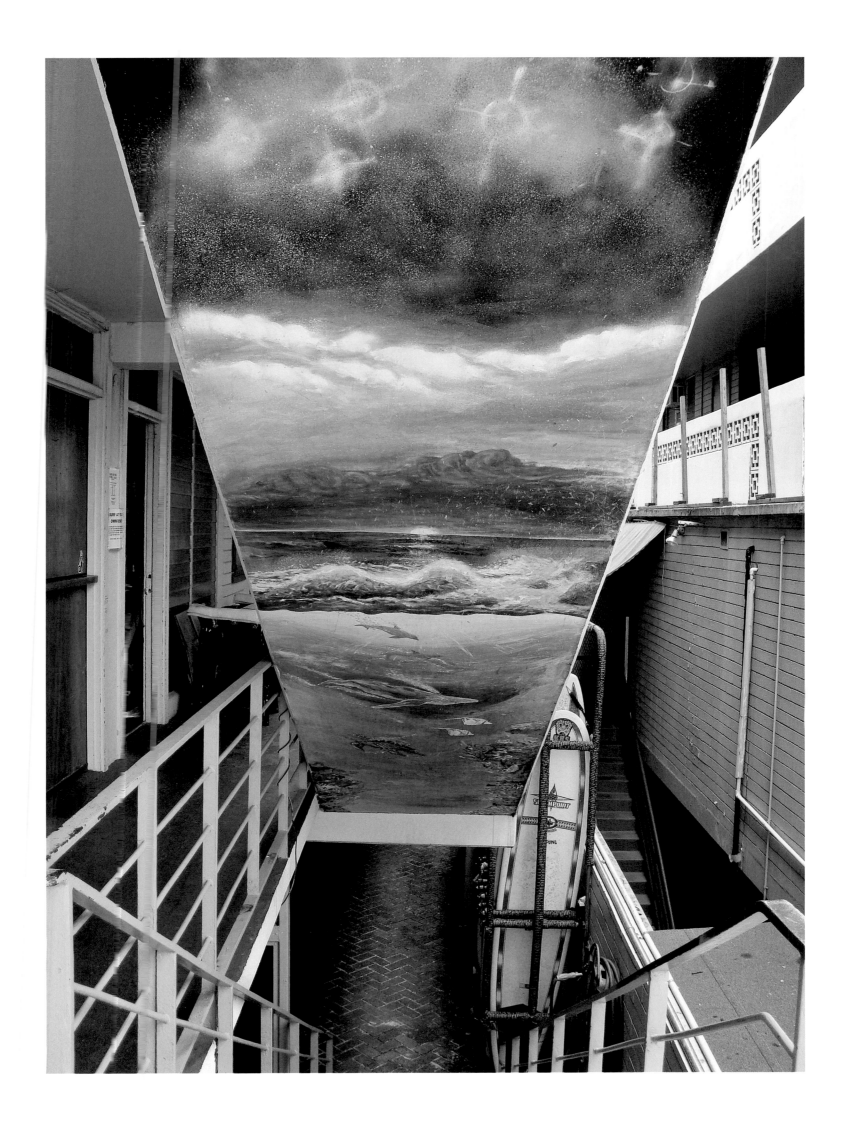

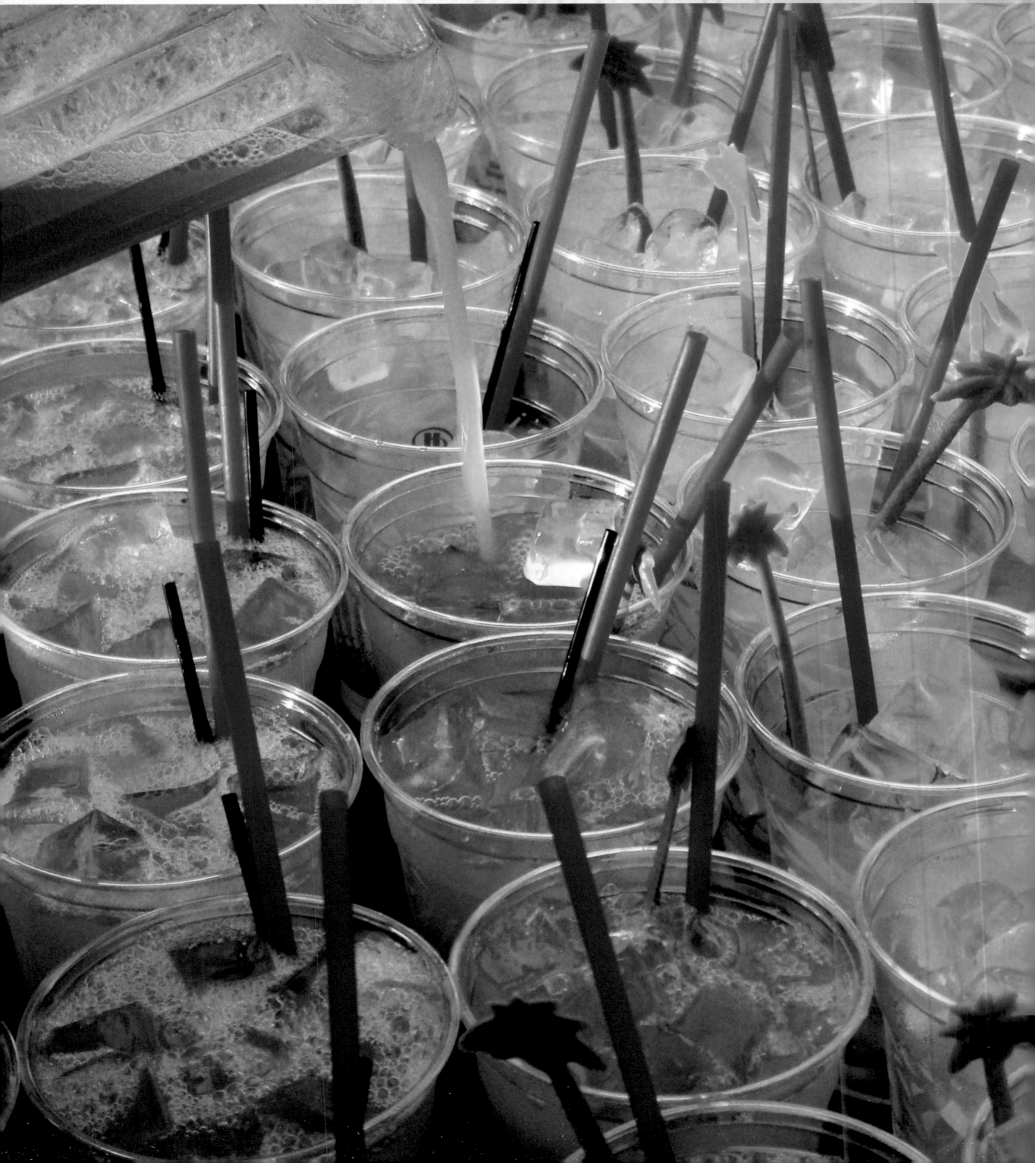

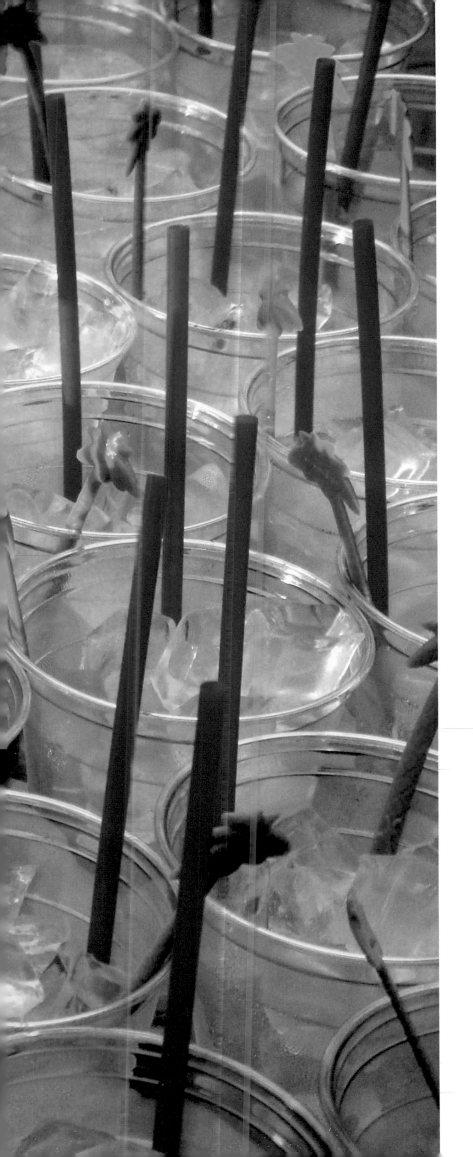

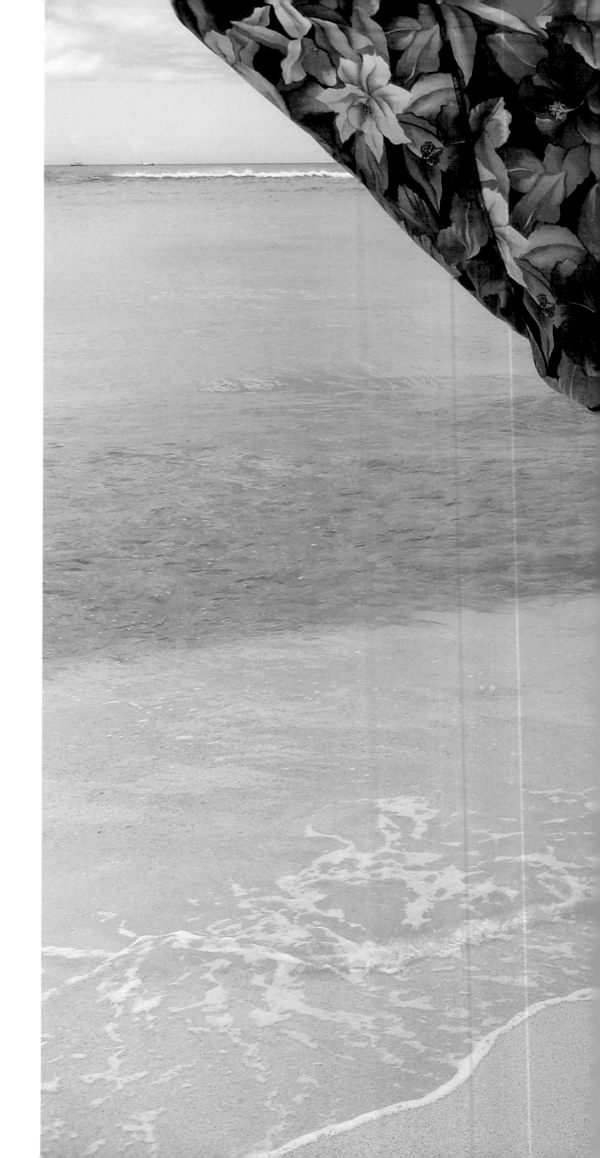

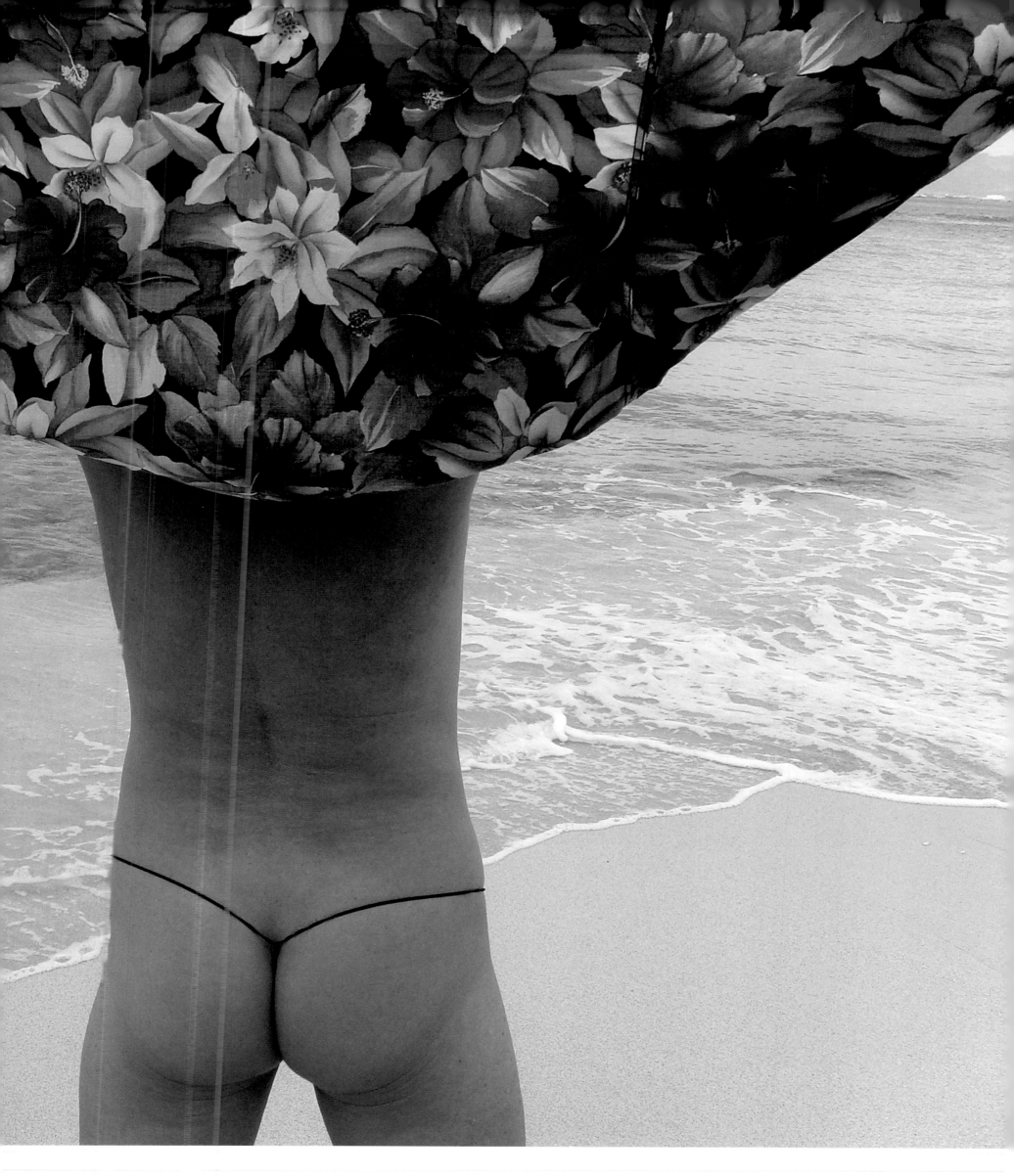

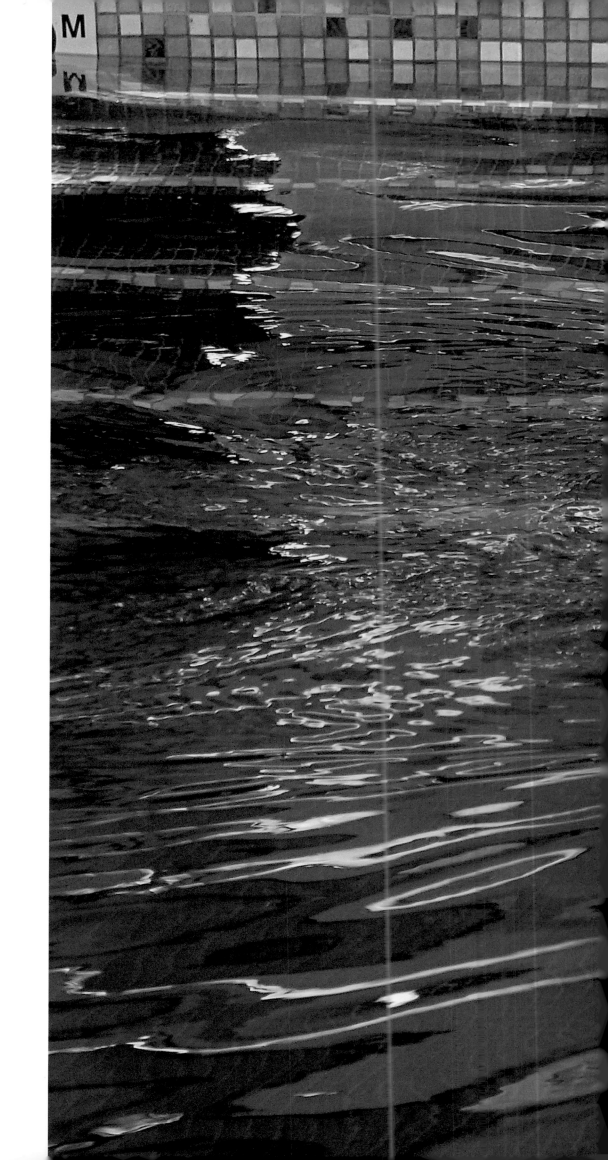

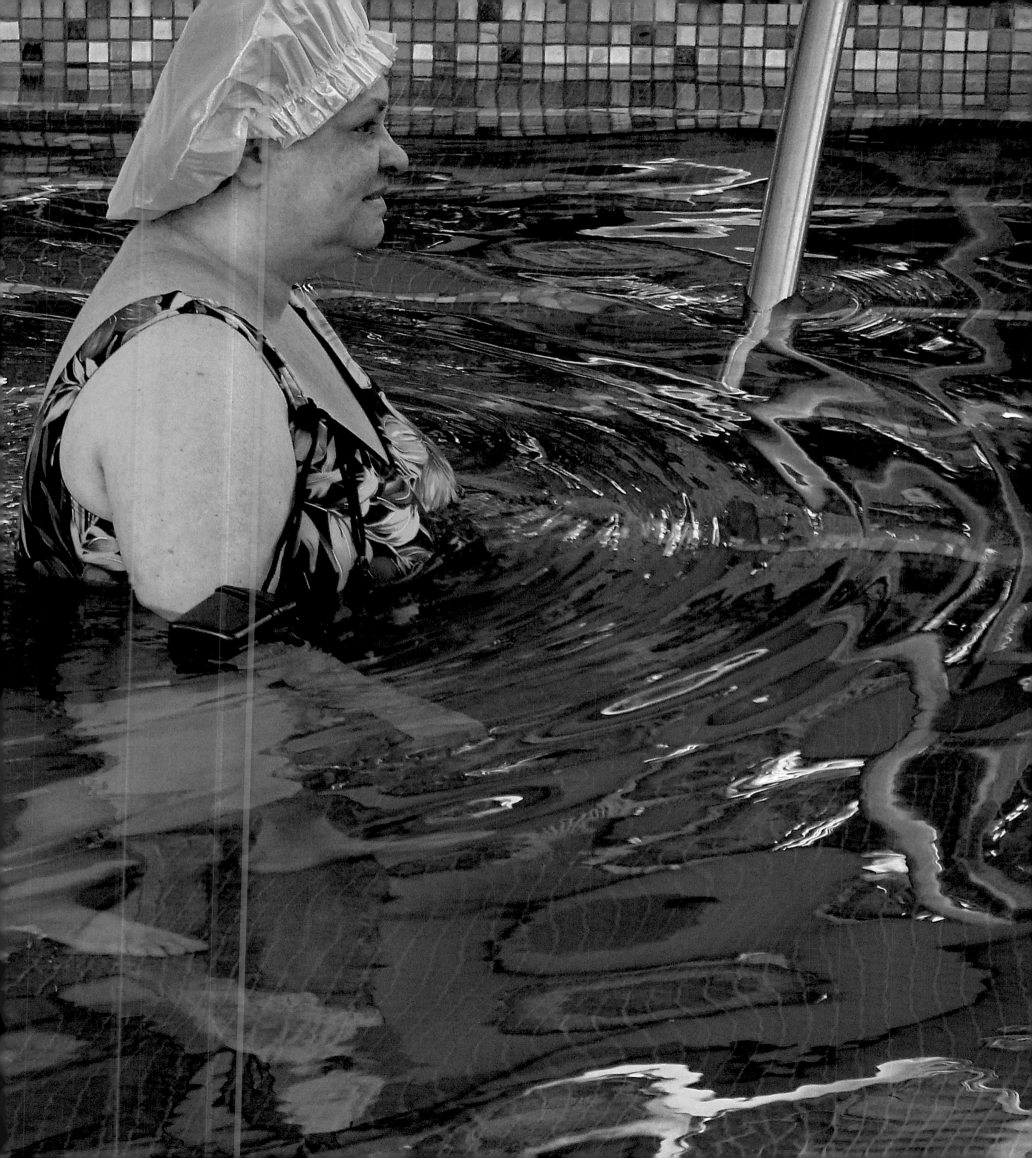

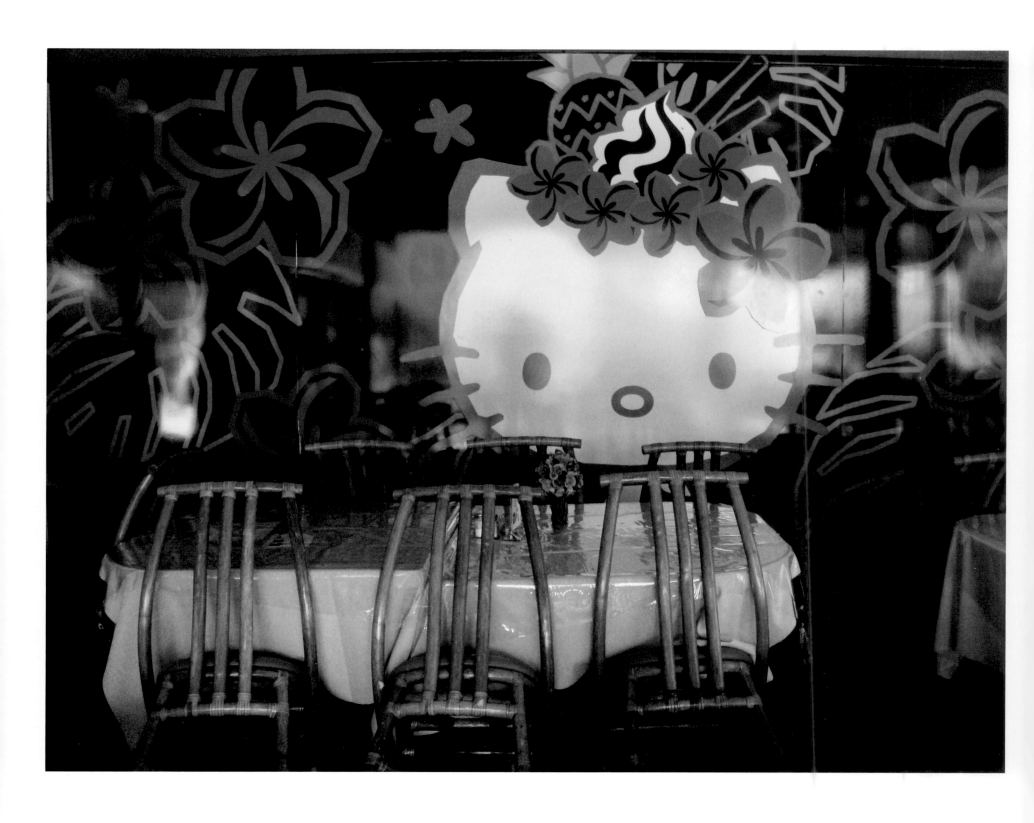

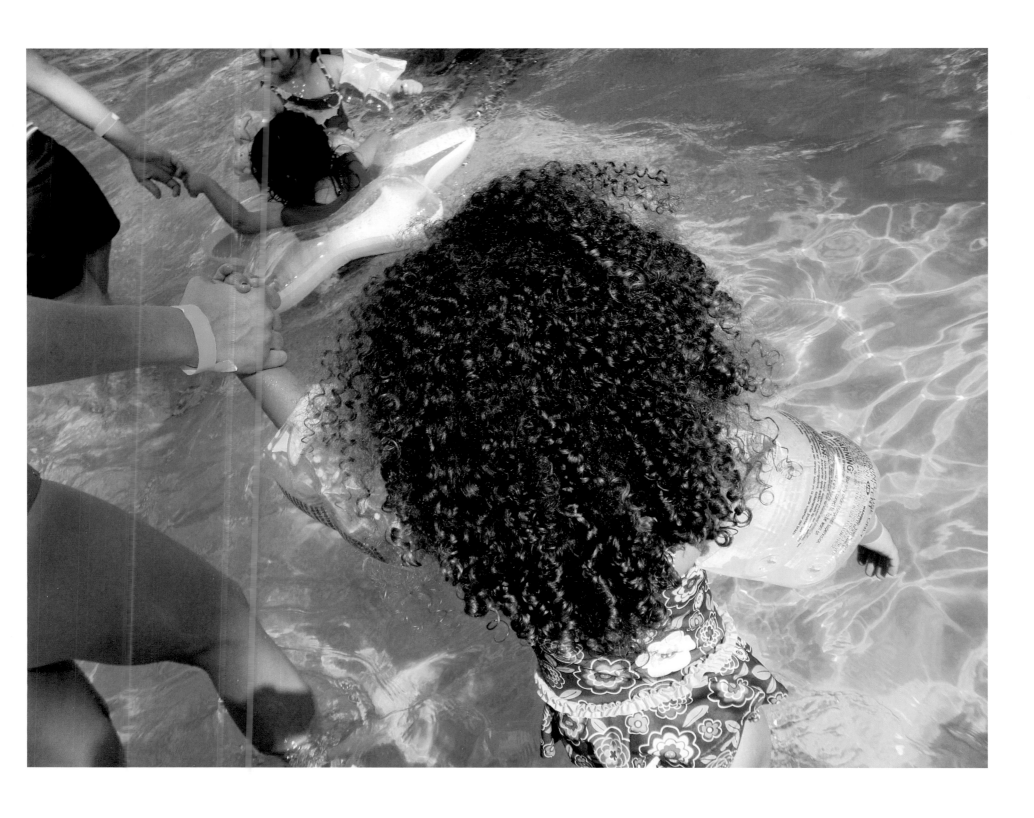

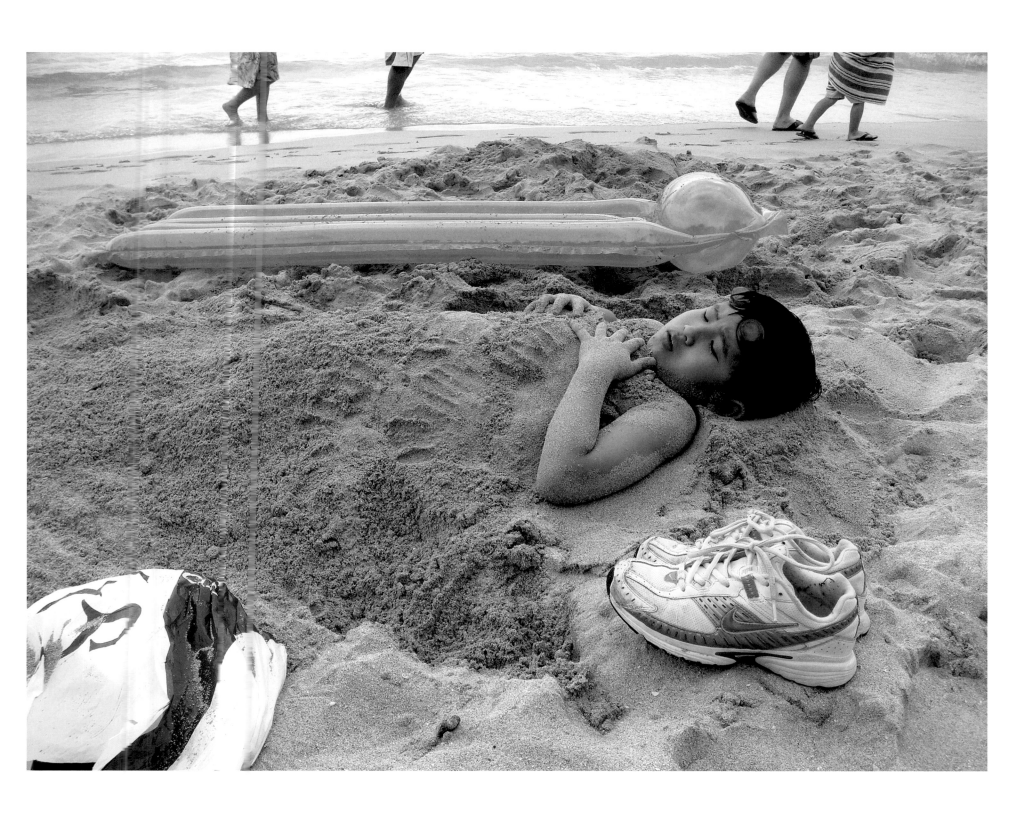

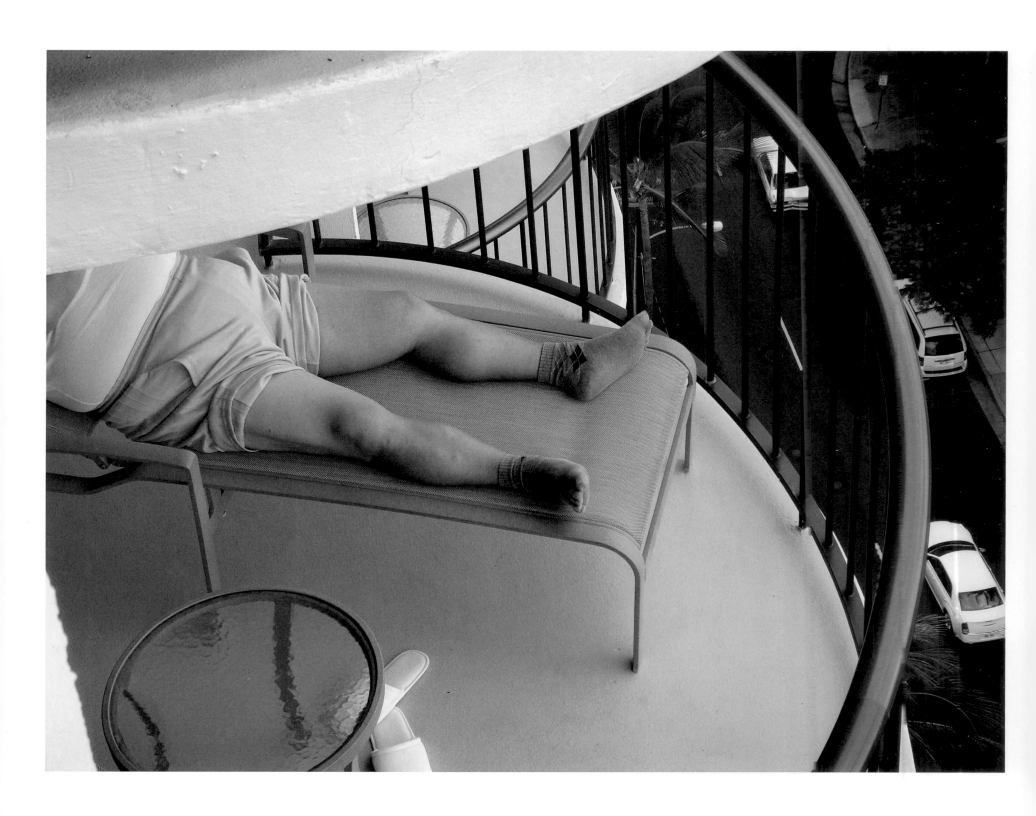

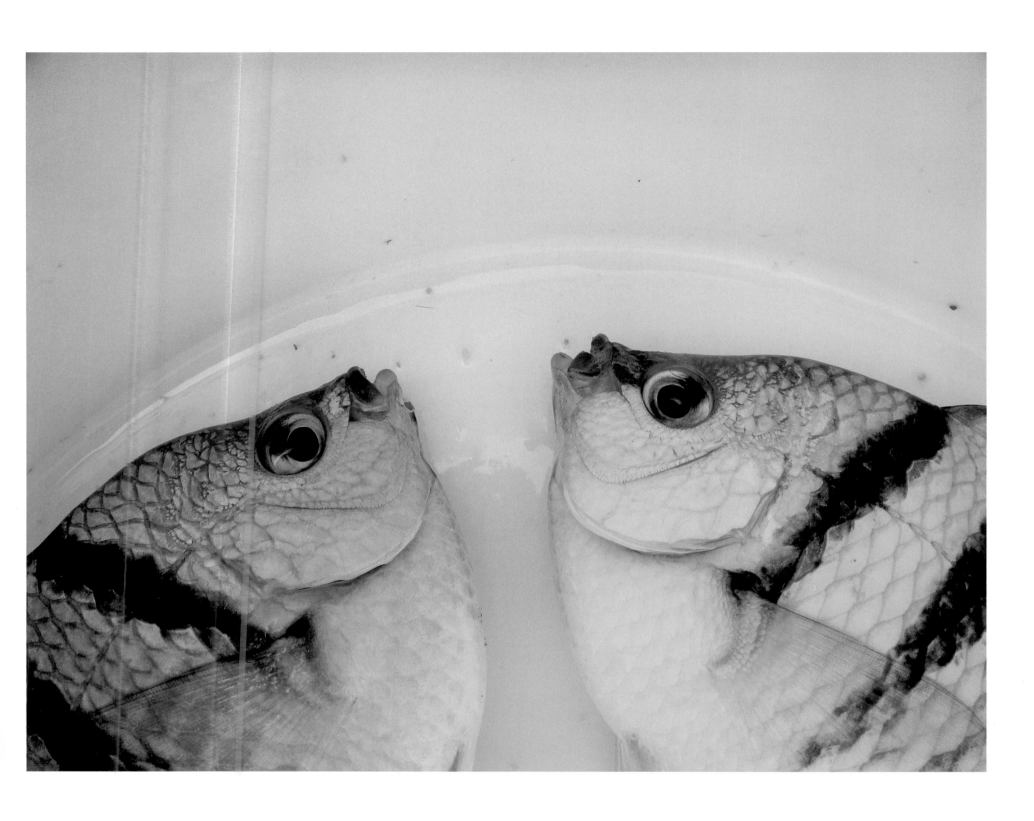

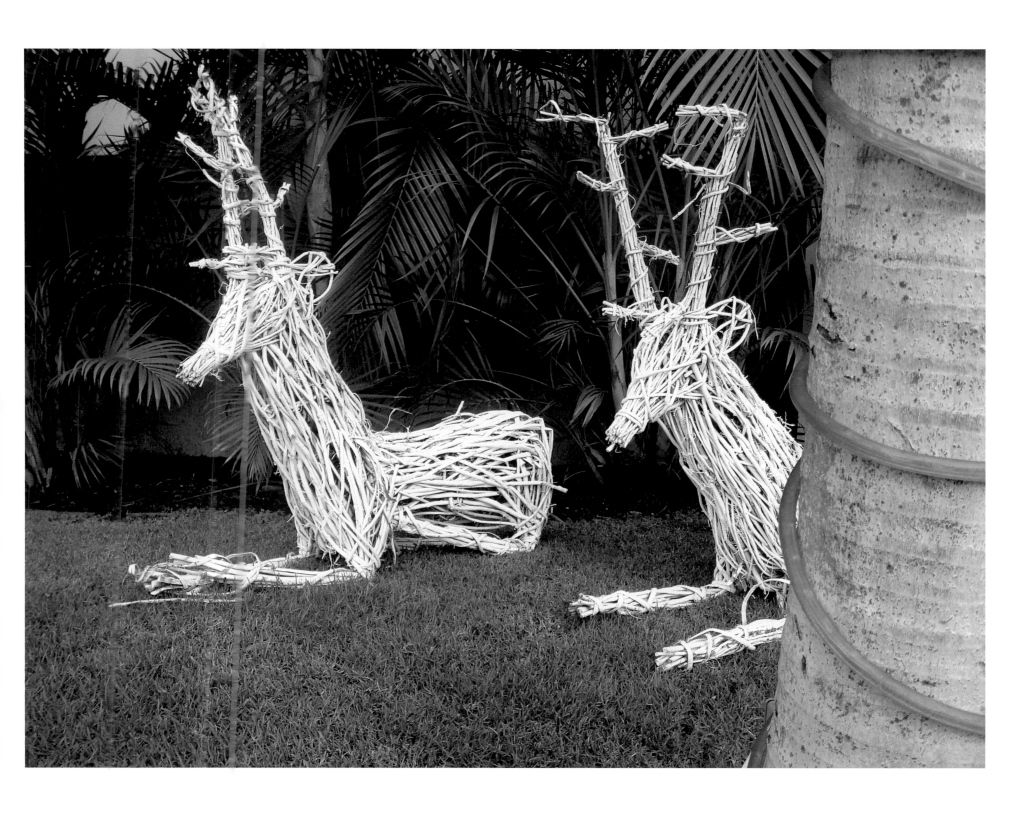

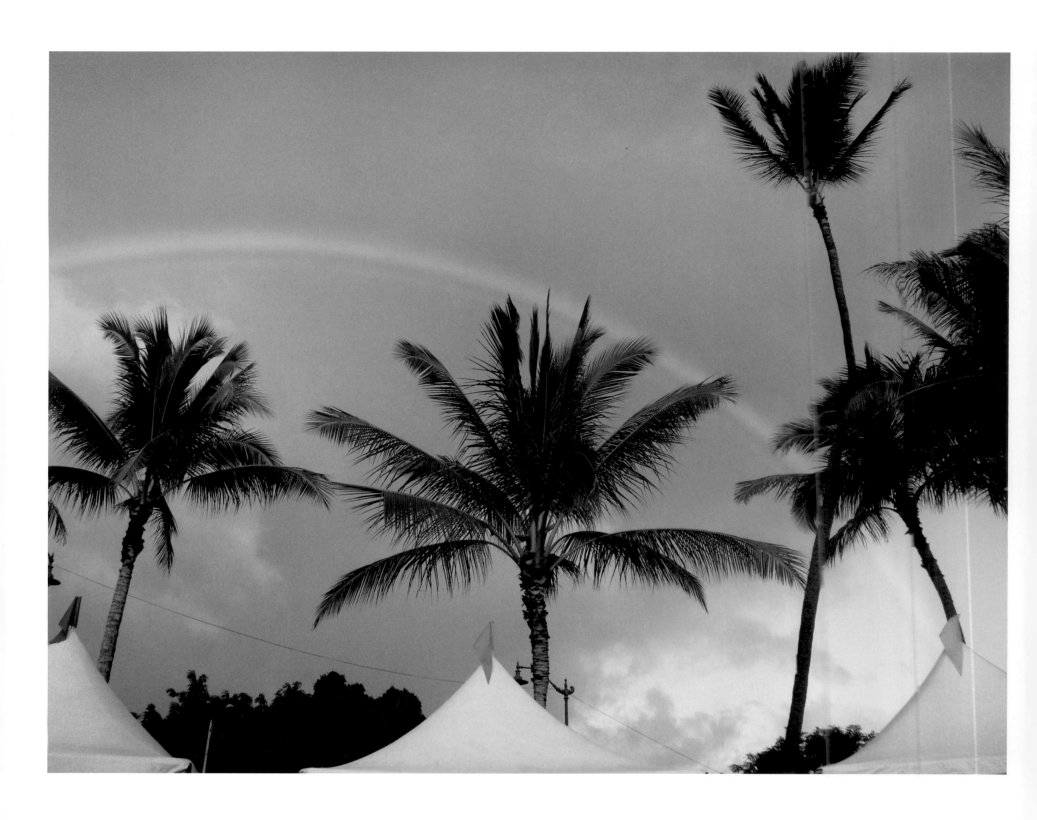

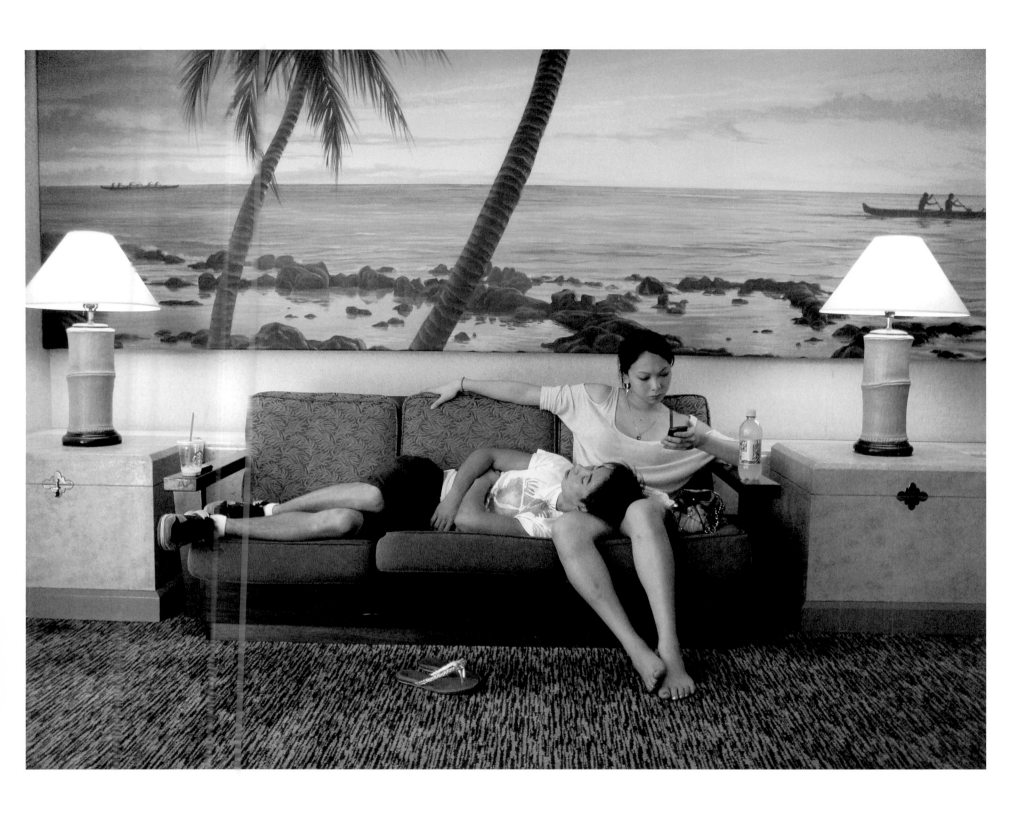

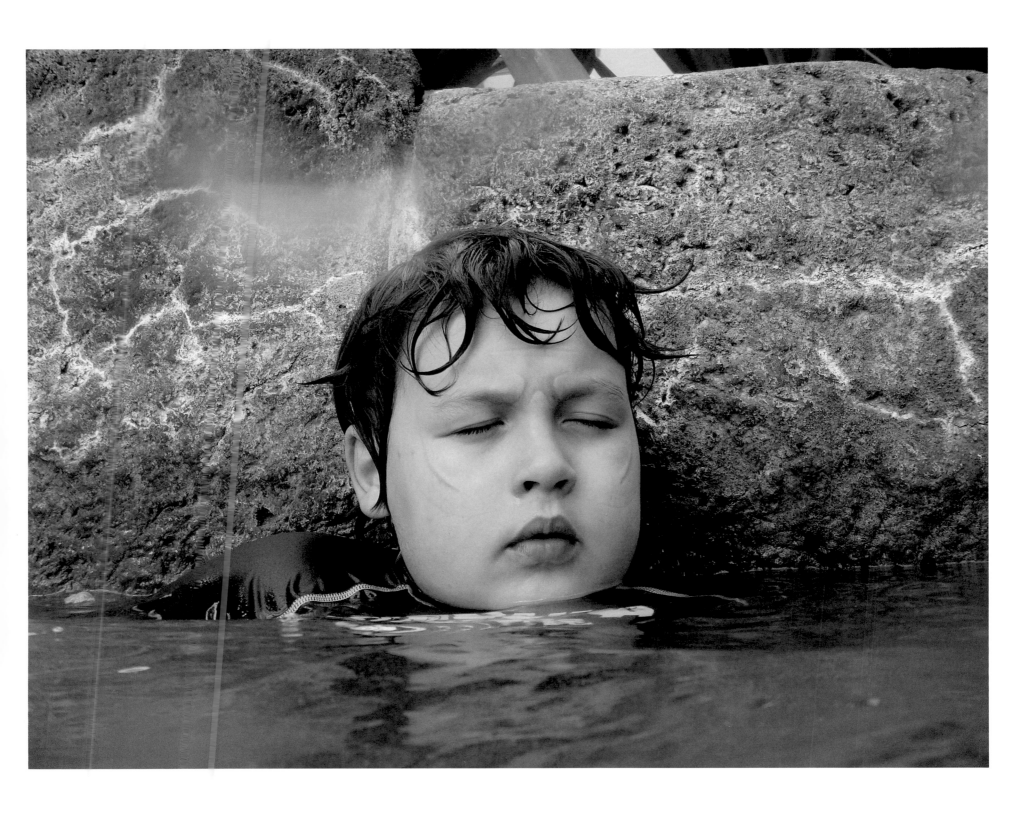

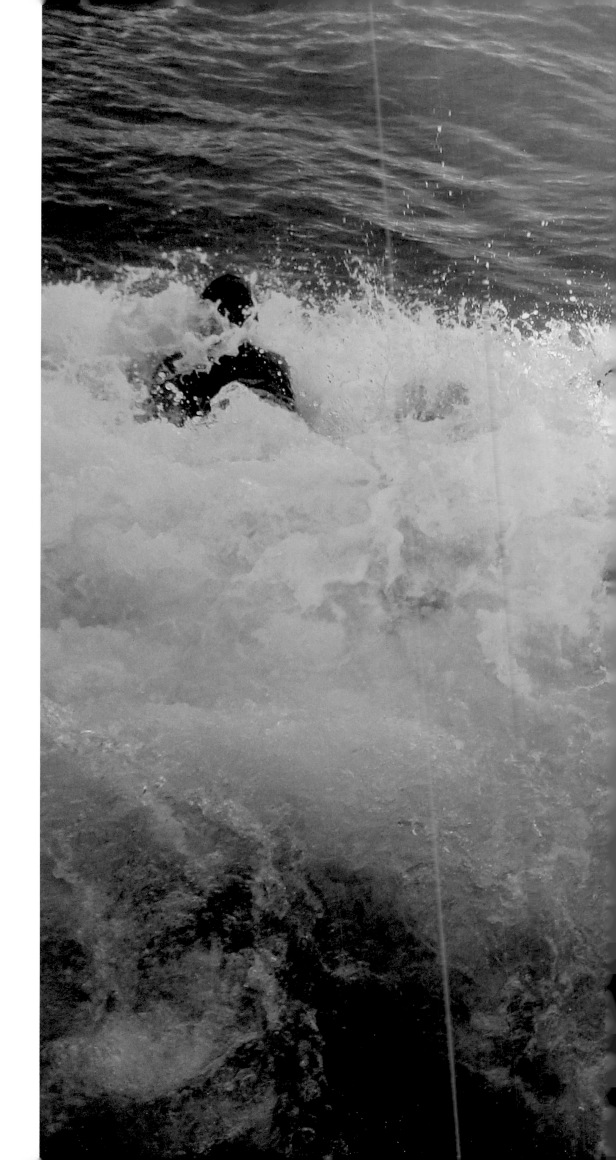

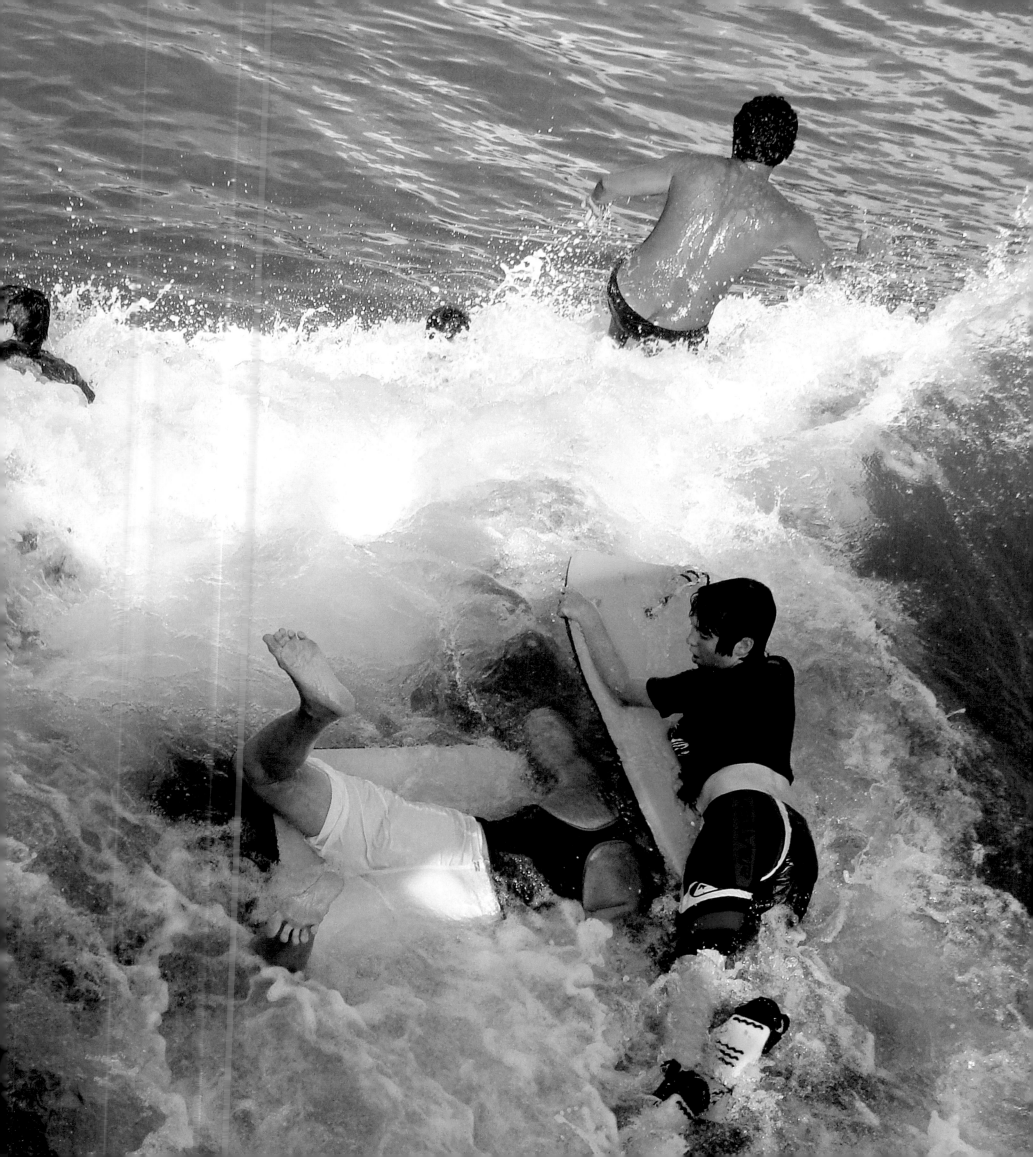

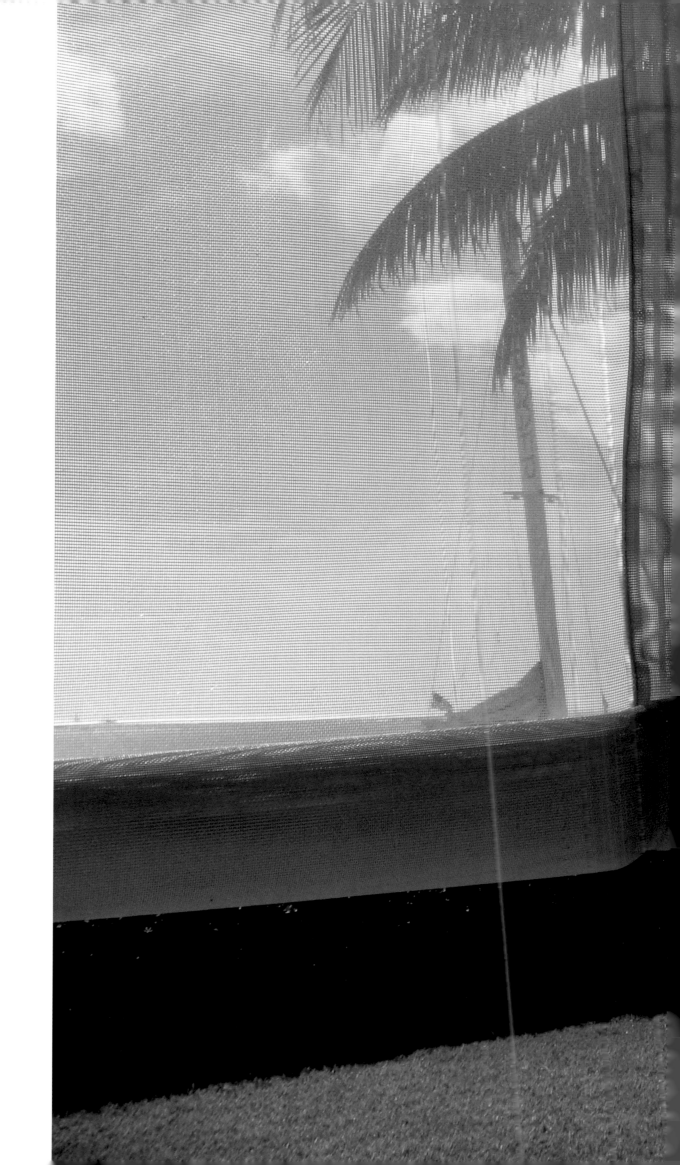

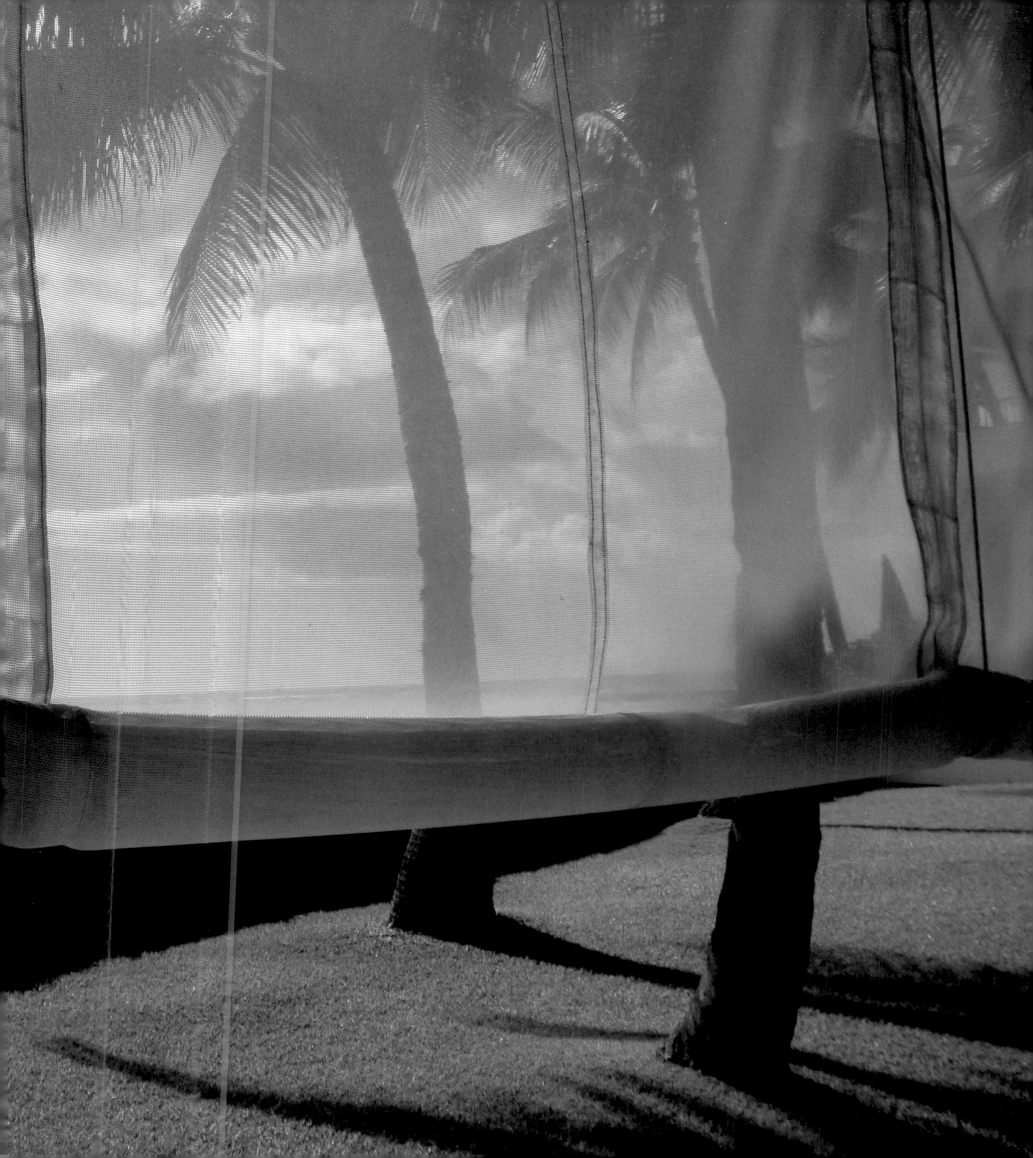

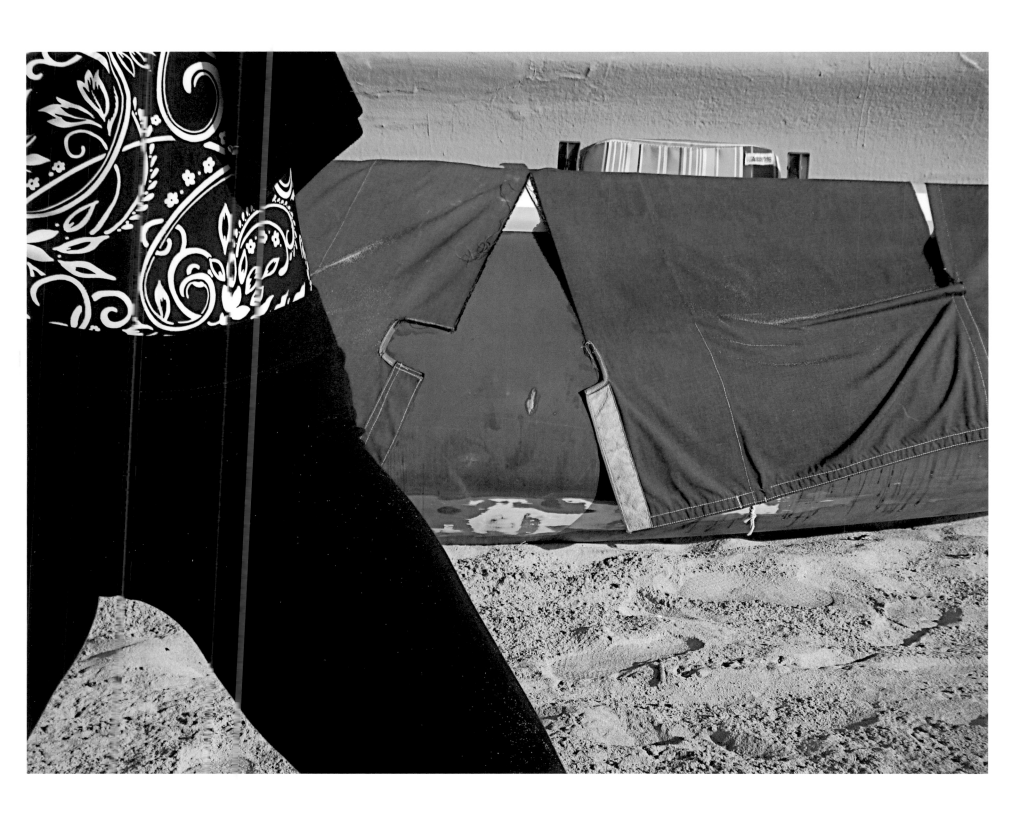

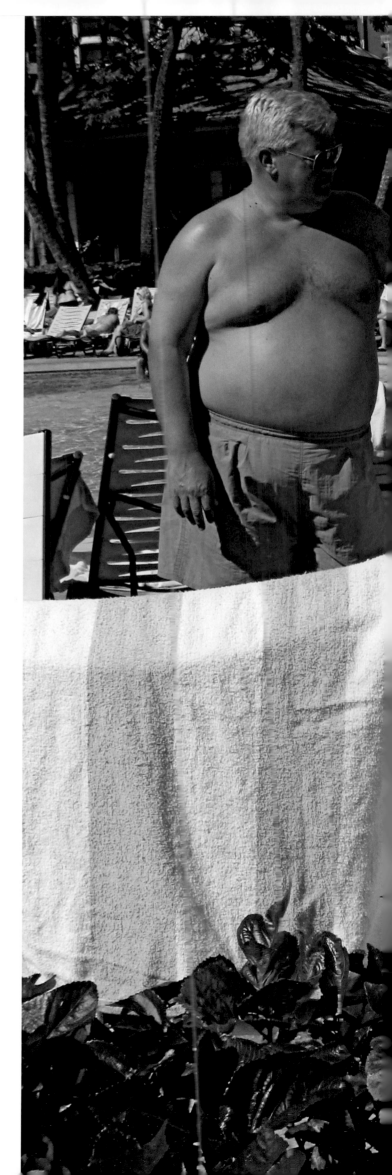

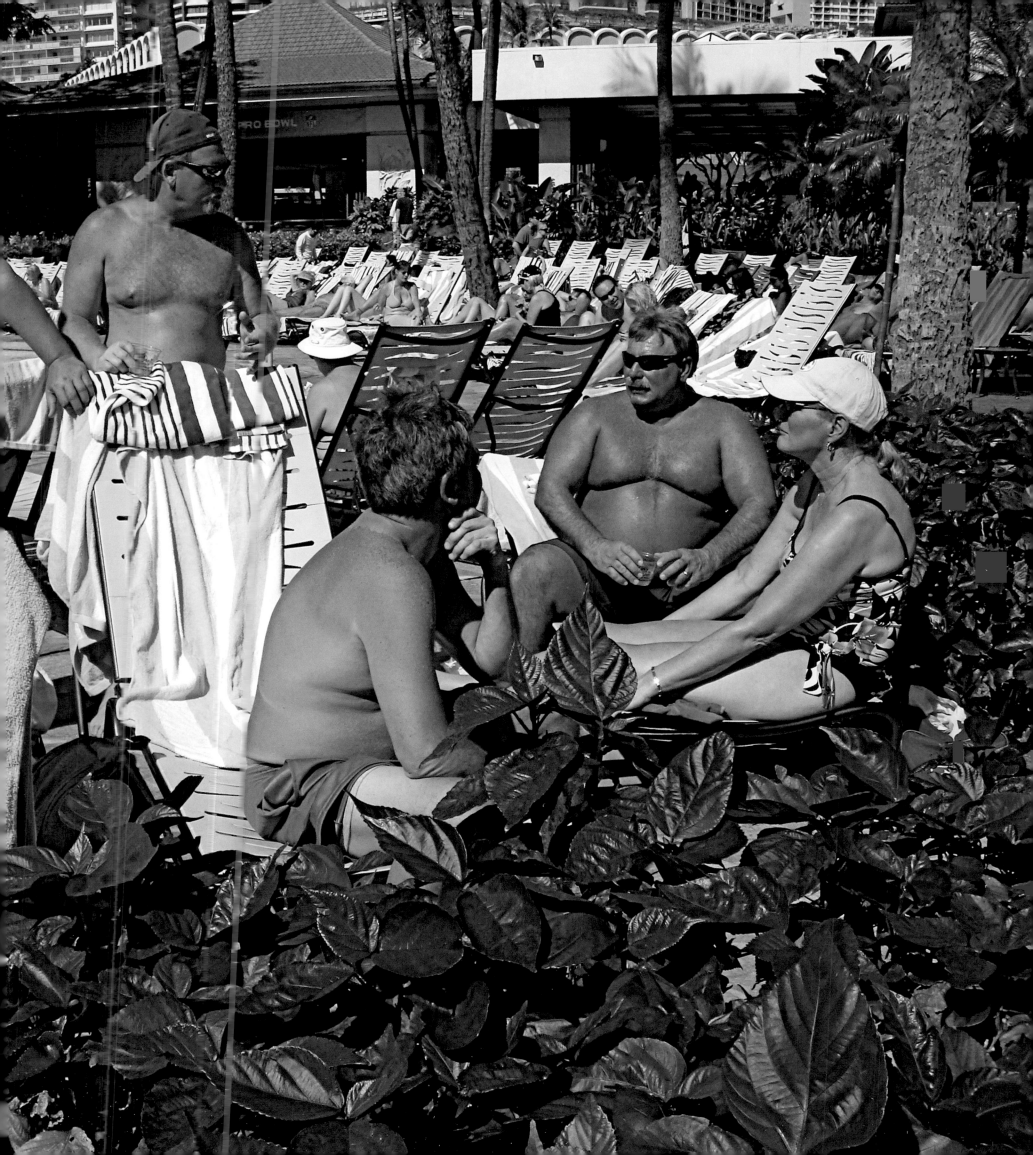

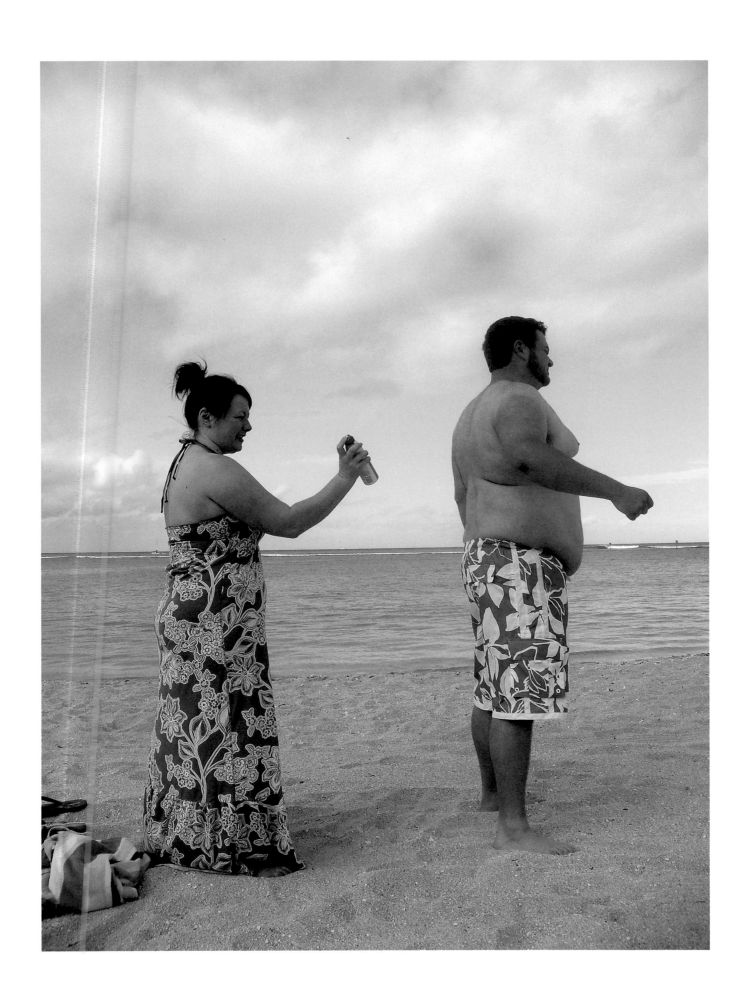

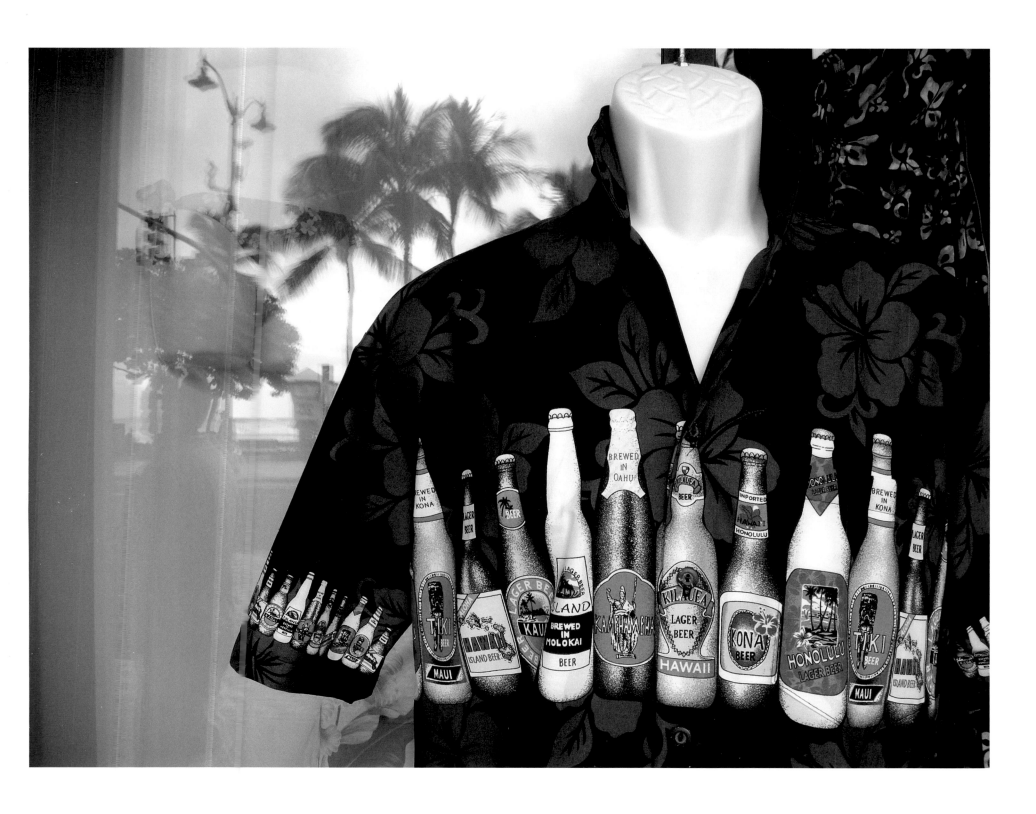

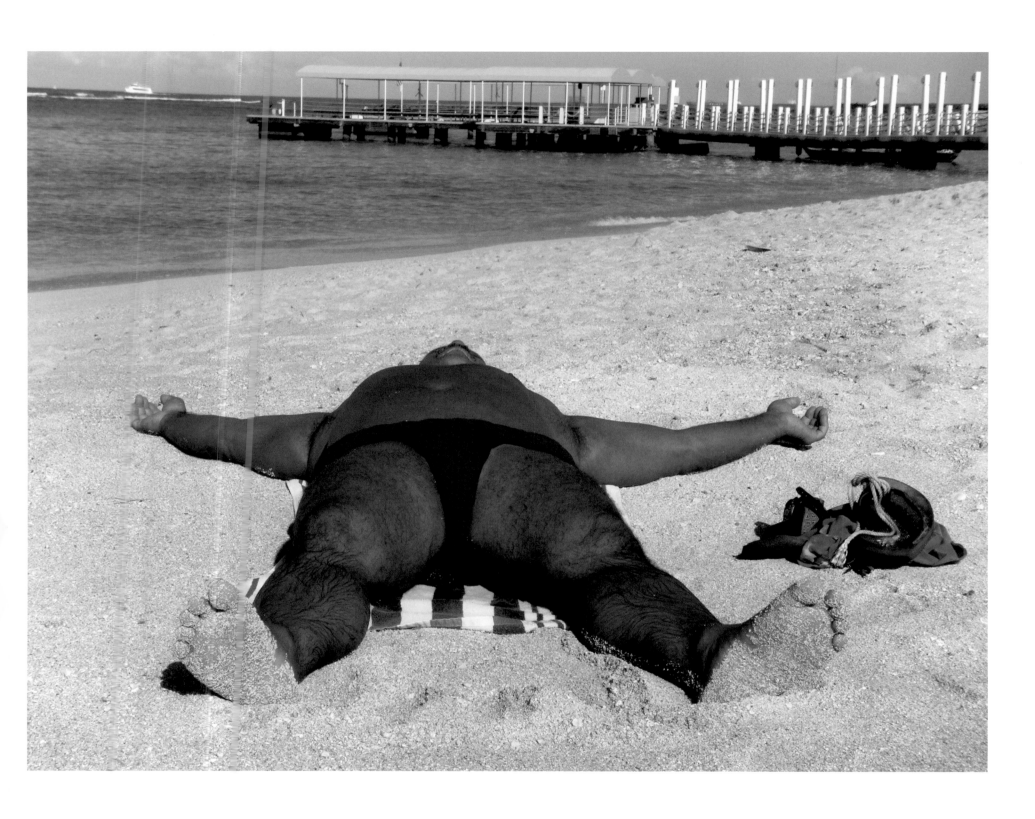

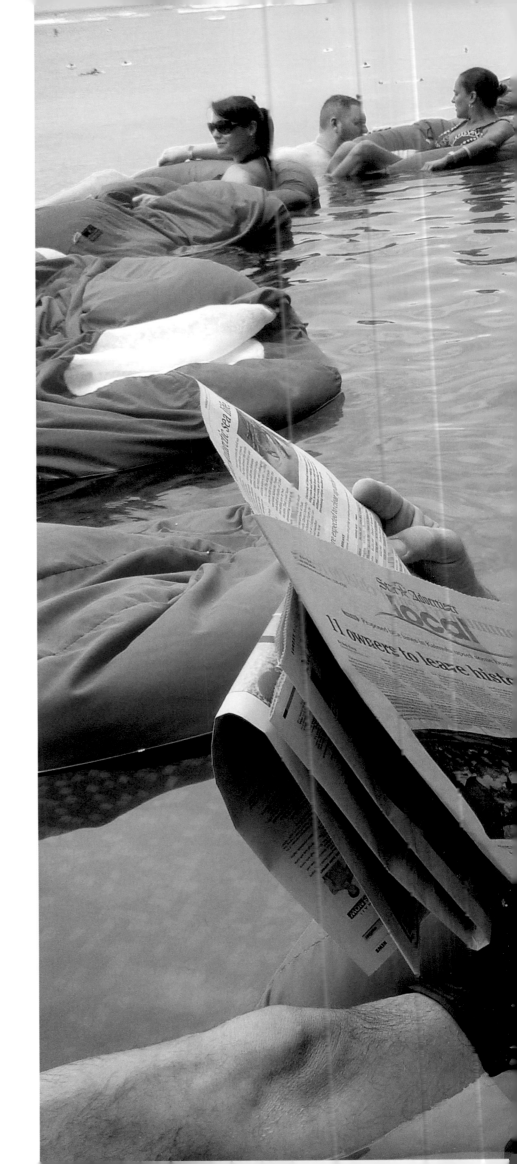

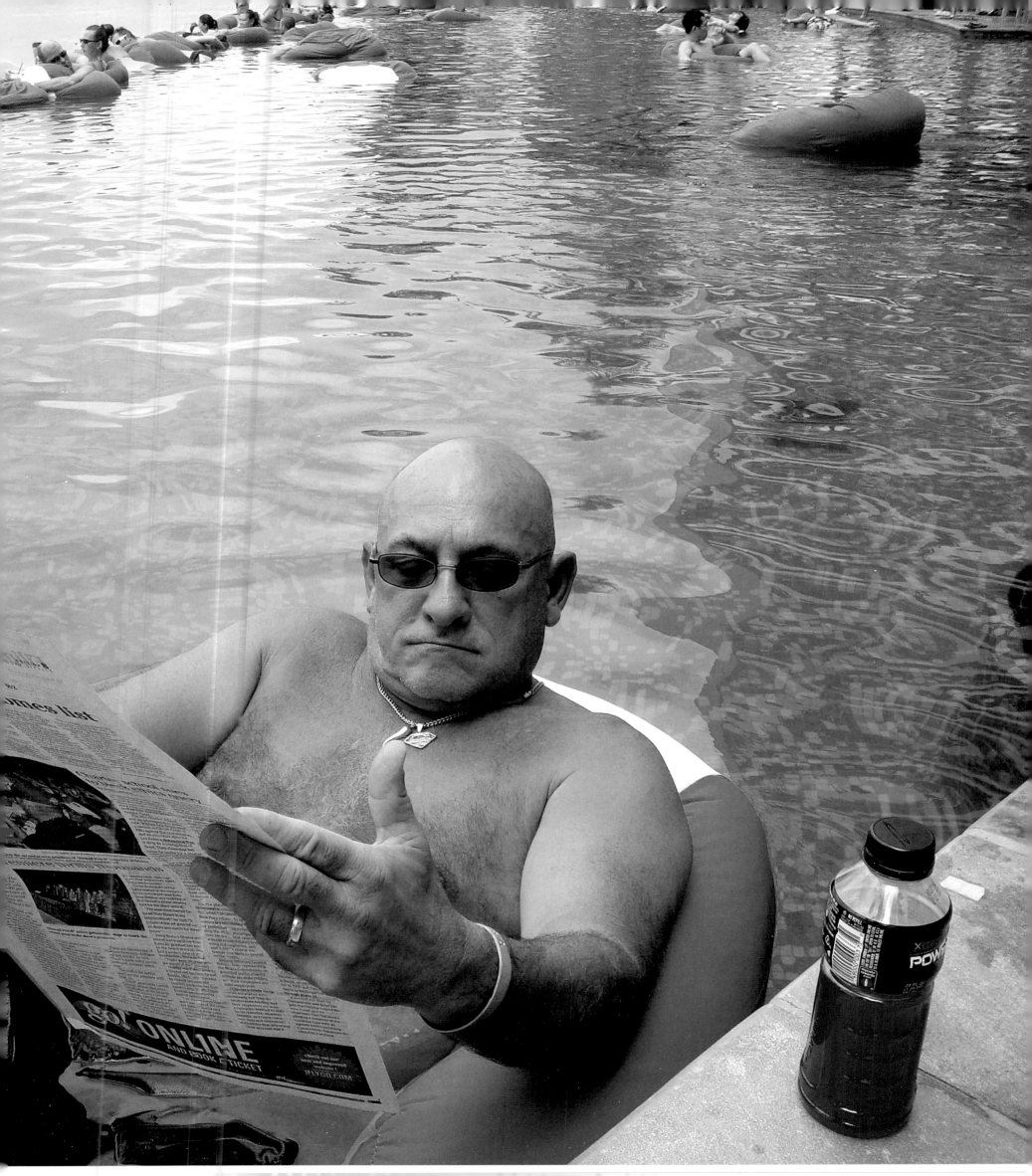

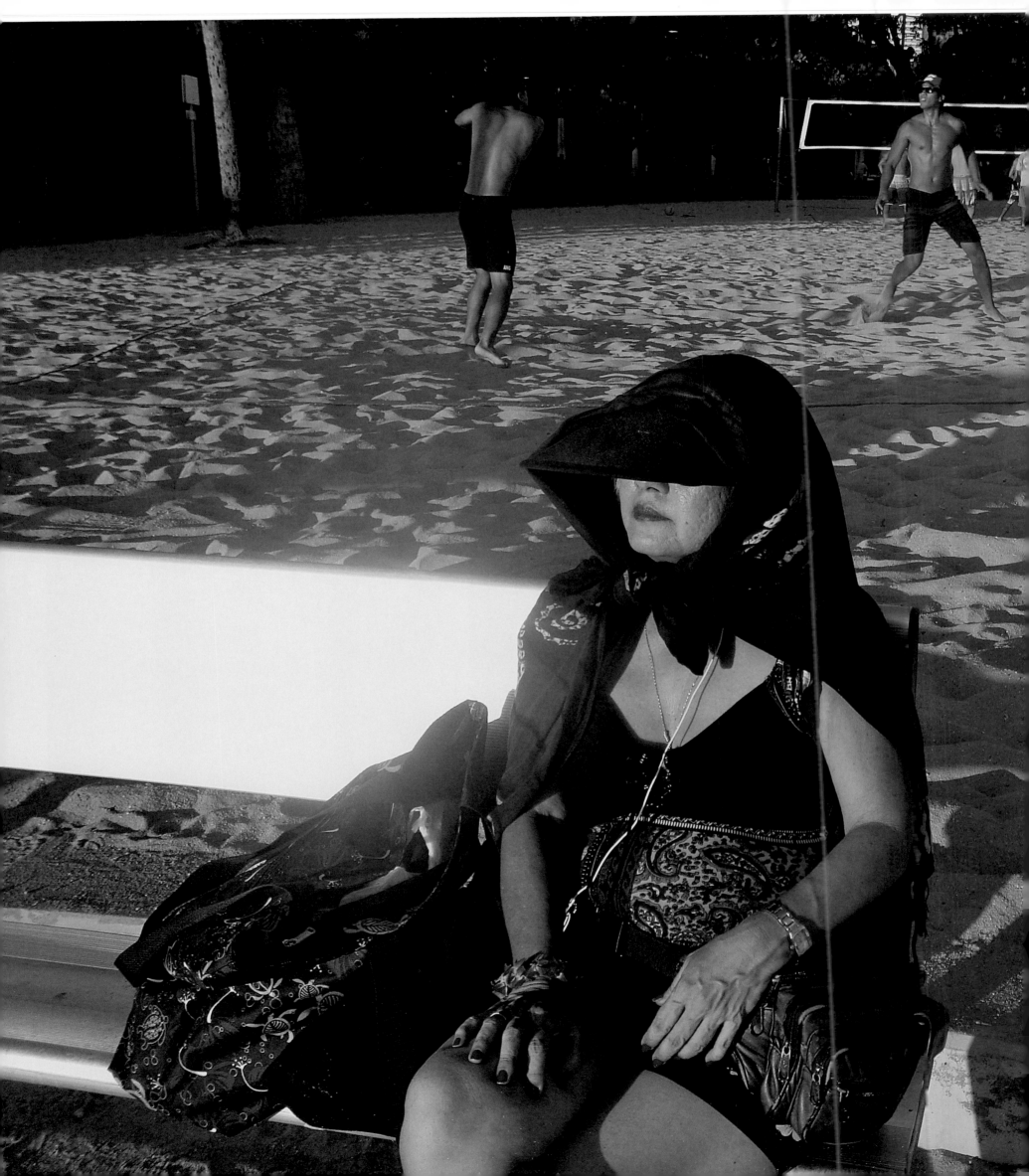

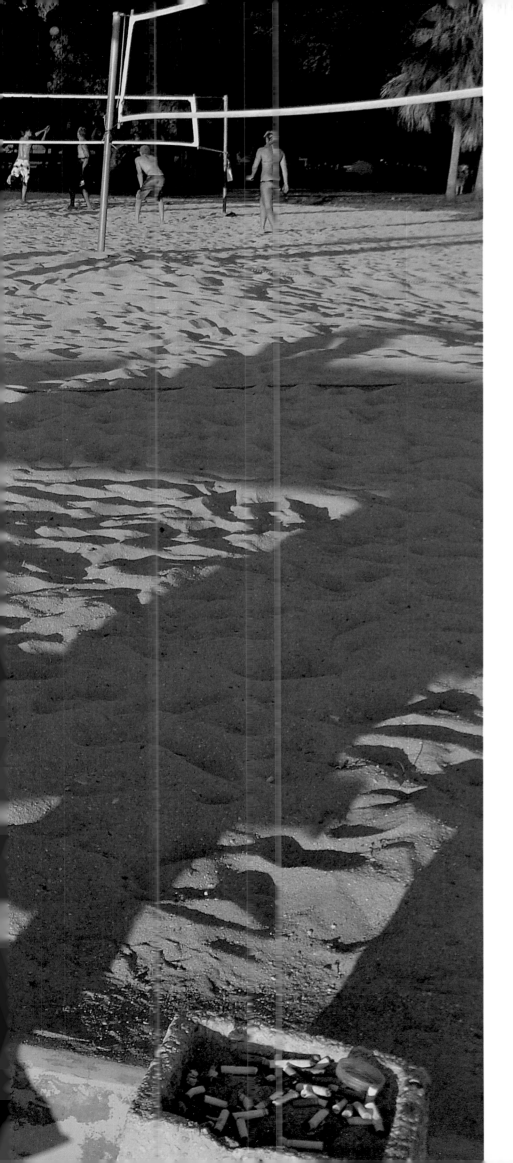

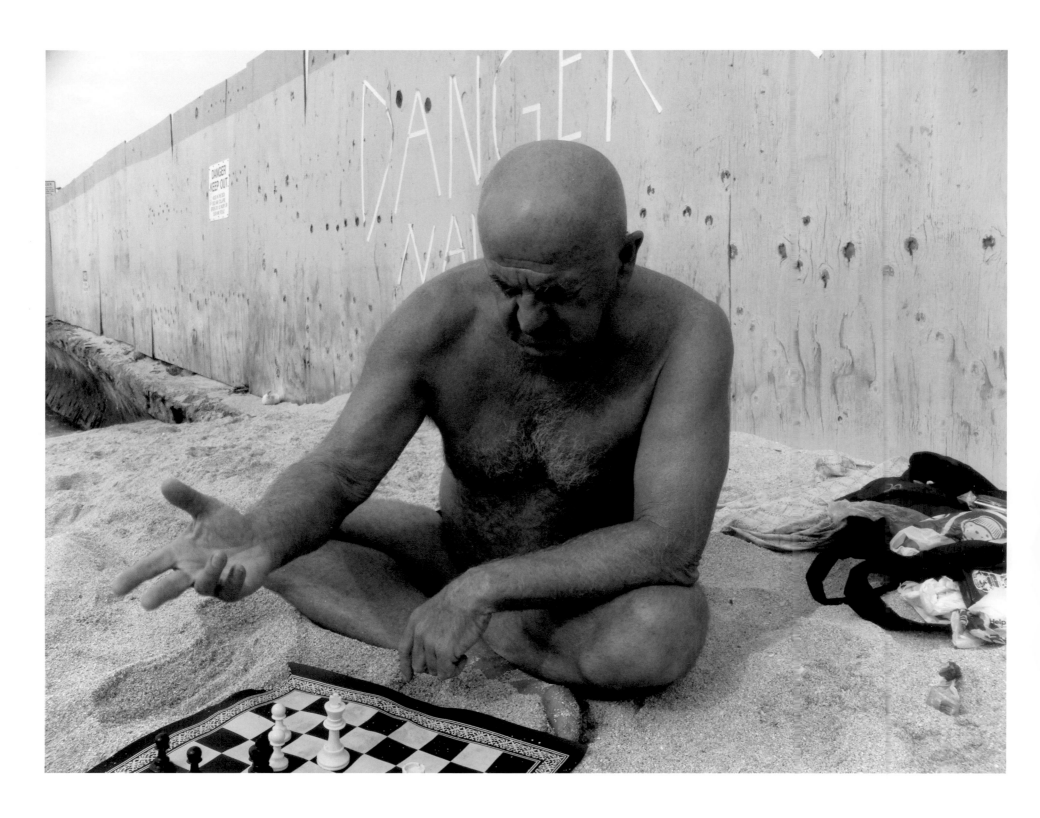

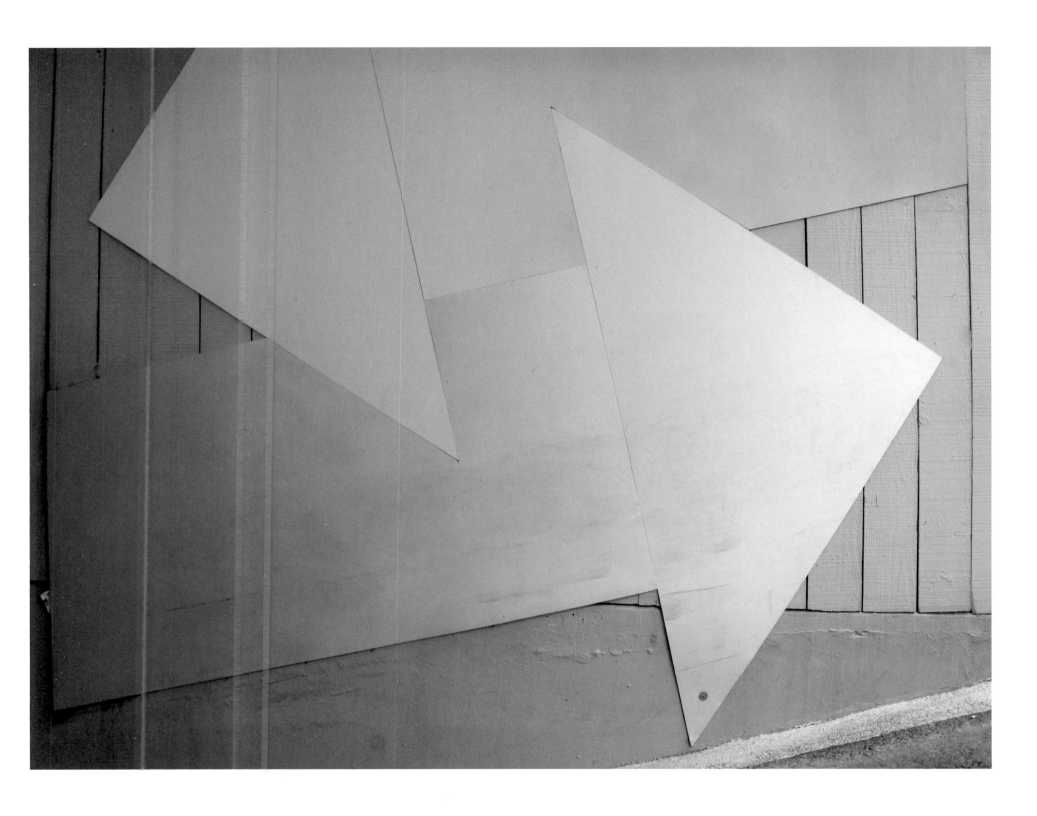

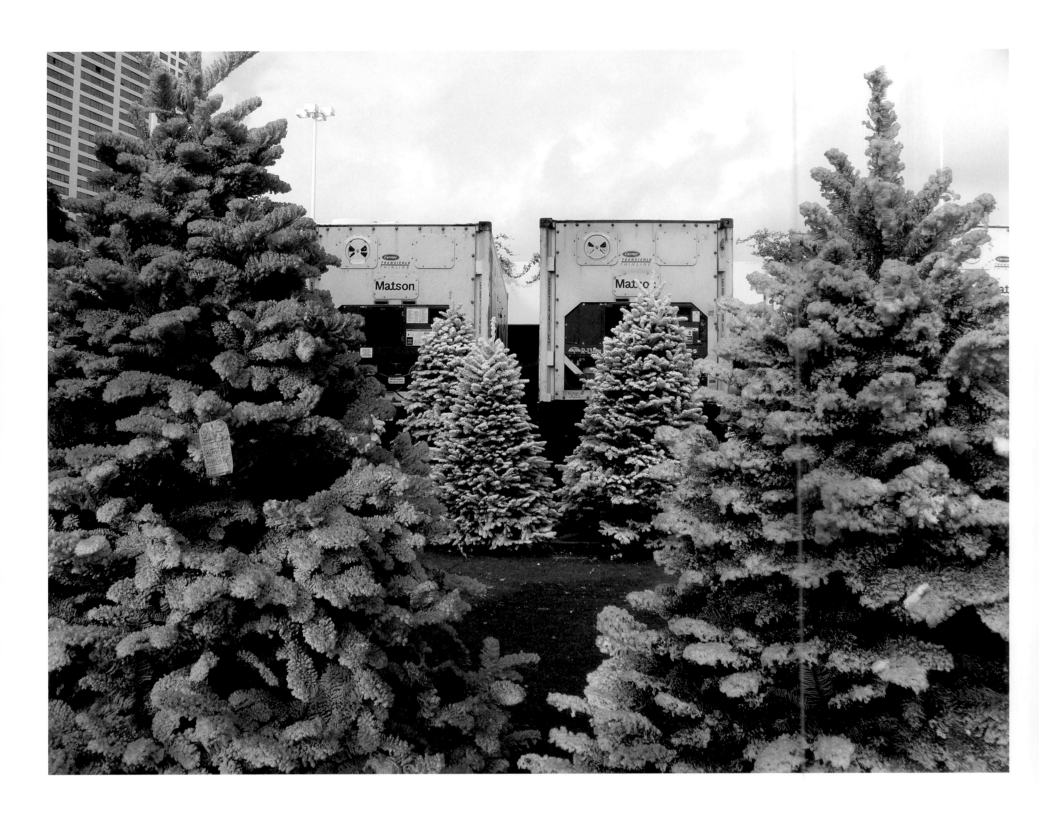

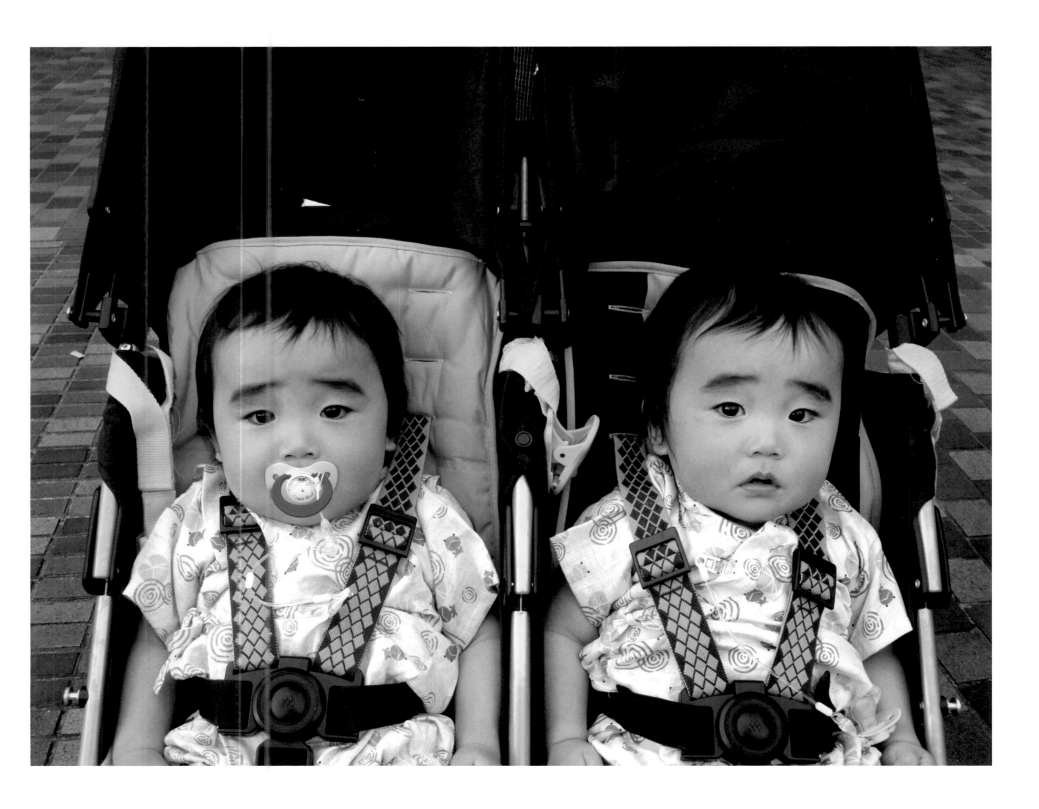

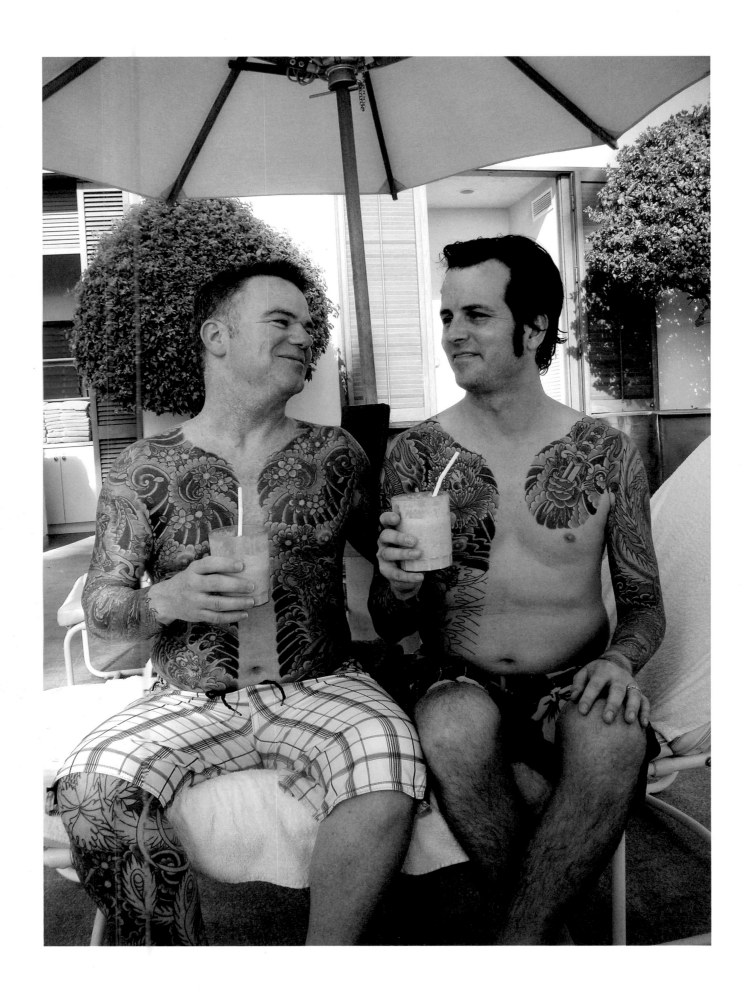

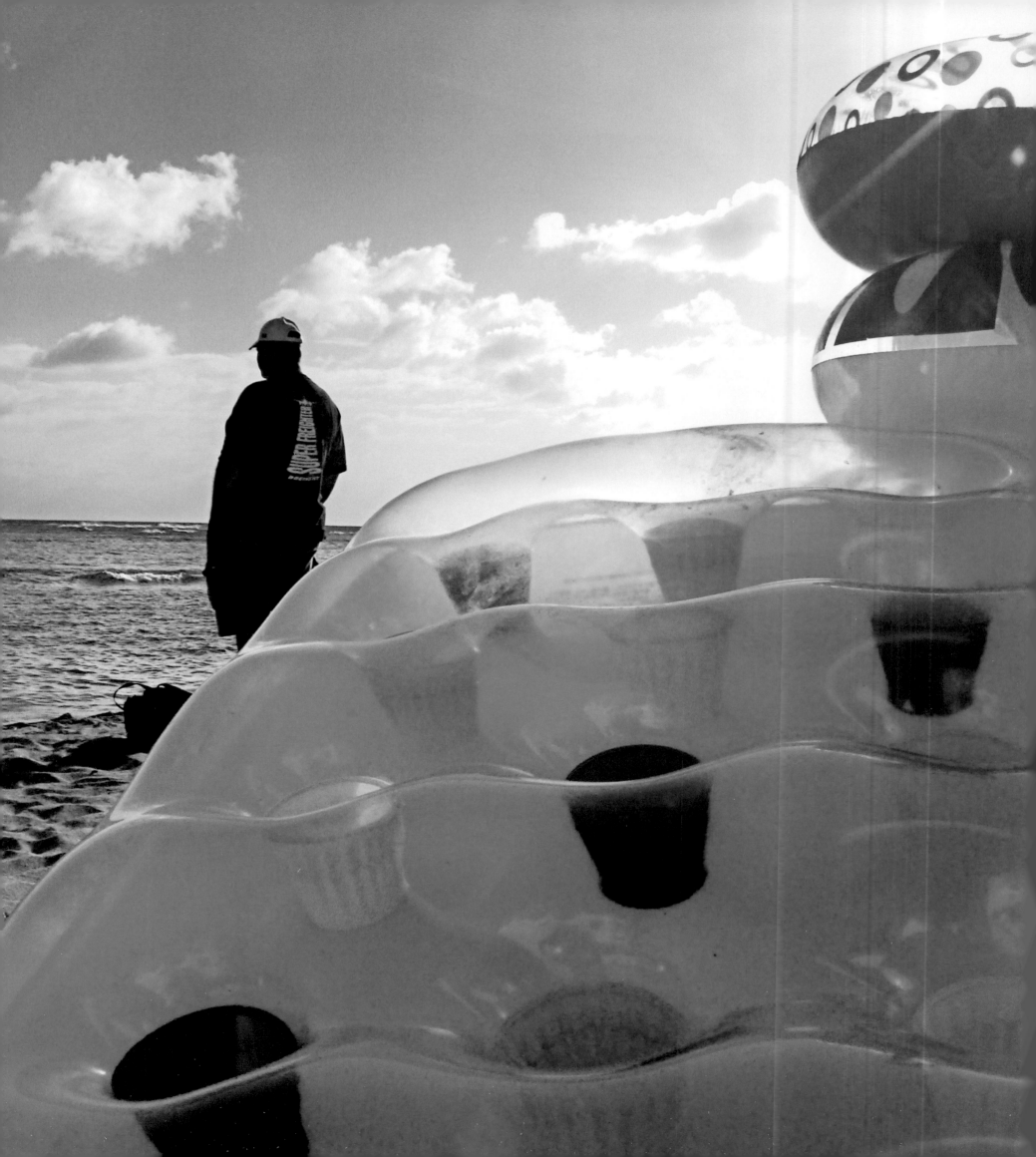

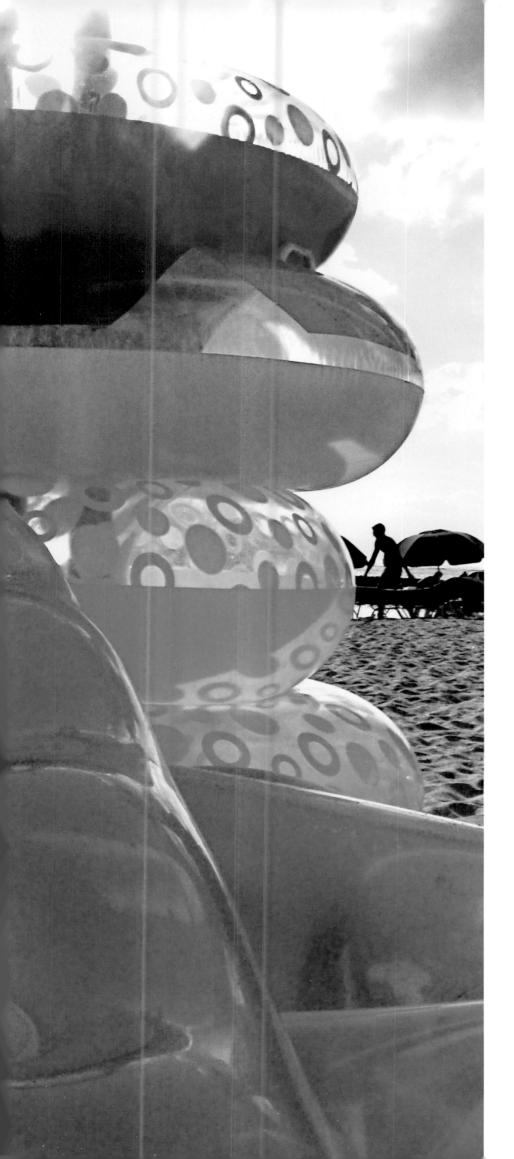

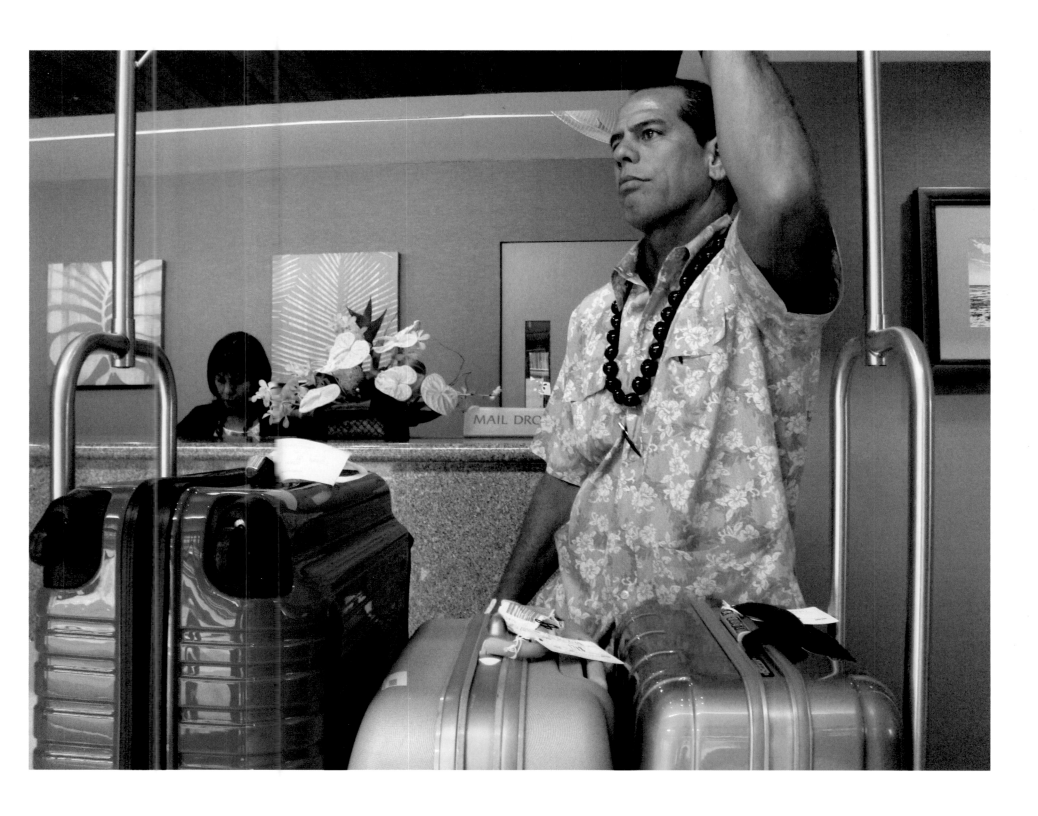

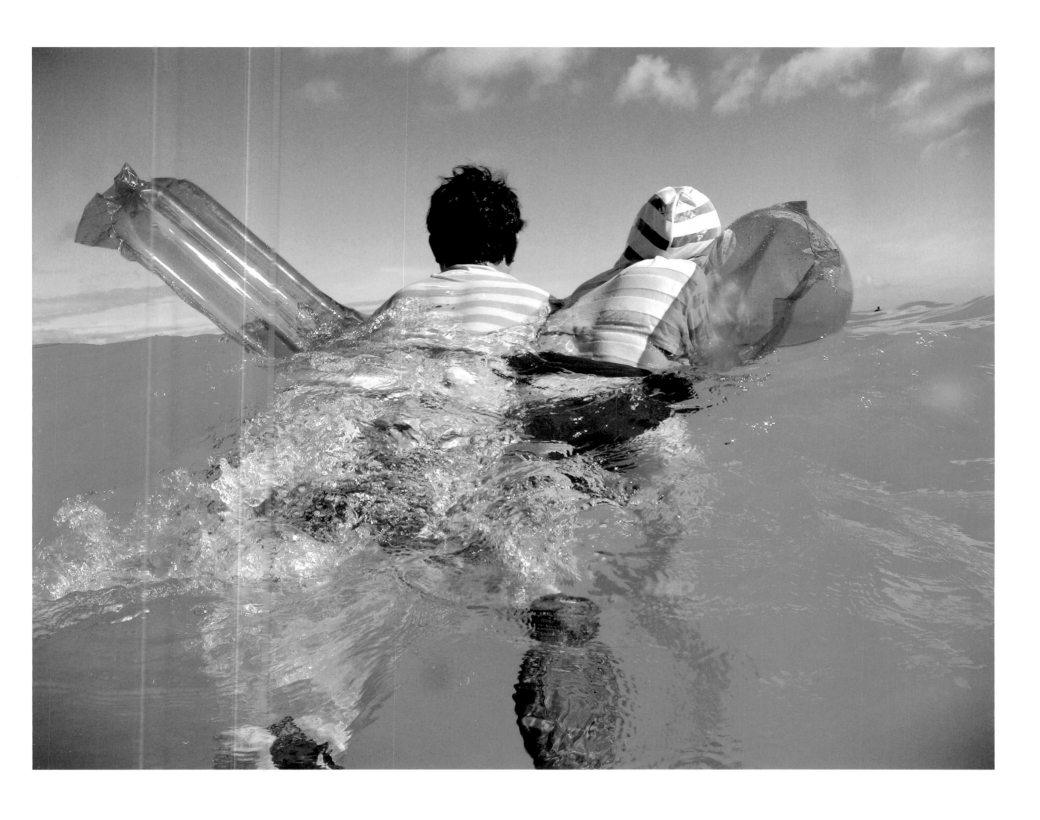

Conjuring Paradise represents my maiden exploration of the world of color photography and my first use of digital equipment. I delighted in how my 5-ounce camera compressed space, heightening the illusionary quality of some scenes. Distances deceive. The newness of color for me revealed a kaleidoscopic explosion of life in all its quirkiness. Eager to blend into the crowds, I slipped this little camera easily in and out of my pocket. I was another tourist, in flip-flops and sunglasses, out to capture and bring home my post-Kodachrome slice of paradise — my flattened view surely as eccentric as those whom I photographed.

This book is a labor of love for my late husband. In July 2010, ten months after his death and exactly a year after our last trip there, I apprehensively returned to Waikiki. I wanted to see if I could do justice both to its visual flamboyance and also to Frank's ebullient spirit and wry but good-natured humor. I hope that the pleasure we both found in taking in this whole pixilated scene has been captured in the preceding pages.

ACKNOWLEDGMENTS

This photographic project would never have happened without of the encouragement and
support of many friends and my family. Among this community I would like to single out a
few of the many: Helen Kimmel, Abby Leigh, Barbara Kendrick, Amy Bonoff, Adam Frampton,
Thomas Frampton, Leah Bendavid-Val, Philip Brookman, Anne Tucker, and Diana Walker.

I depended especially on my good friends Sarah Greenough and John Gossage for critical
visual feedback, sequencing of images, and imagining the possibilities of the photo book.

I was thrilled and honored when Poet Laureate and Pulitzer Prize–winning poet Kay Ryan,
with exquisite grace, gifted me "Slant" for this book.

I cherished every minute of working with David Chickey and his team at Radius.
Their creativity, sensitivity and sense of collaboration made the process wonderfully fun.

Finally, I would be remiss if I did not share John Gossage's words of wisdom when
I complained about how emotionally draining it was for me to continue to return to Waikiki.
He deadpanned, "Betsy, just think of it as war photography with room service."

RADIUS BOOKS

227 East Palace Avenue, Suite W, Santa Fe, New Mexico 87501 radiusbooks.org

PUBLISHER & CREATIVE DIRECTOR: David Chickey

PRODUCTION DIRECTOR: David Skolkin

Available through

D.A.P. / DISTRIBUTED ART PUBLISHERS

155 Sixth Avenue, 2nd Floor, New York, New York 10013 artbook.com

ISBN 978-1-934435-67-0

Library of Congress Cataloguing-in-Publication Data available from the publisher upon request.

Permission for use of Kay Ryan's poem "Slant," published in *The Best of It: New and Selected Poems* (New York: Grove Press, 2011), courtesy of the author.

Design: David Chickey
Color Separations: John Vokoun
Proofing: Laura Addison
Printed in Italy